# WHAT'S MISSING?

## Realising our photographic potential

**Compiled by Eddie Ephraums**

First published 2000 by Argentum, an imprint of
Aurum Press Ltd, 25 Bedford Avenue, London, WC1B 3AT.

All photographs courtesy of the Trevillion Picture Library and its
photographers, 75 Jeddo Road, London, W12 9ED.
www.trevillion.com

A catalogue record for this book is available
from the British Library.

ISBN 1 902538 08 0

Origination - Graphic Ideas, London, N1
Printed in Singapore by Imago

Front cover photographs
Top row, from left to right: Alun Callendar, Stuart Knowles and Alexandra Murphy
Bottom row: left to right: Andrew Davis, Stuart Knowles and Allan Baxter
Title page photograph
Andrew Davis

With special thanks to the
**Trevillion Picture Library**
and its photographers

# Contents

# Introduction - Eddie Ephraums

**What's Missing?** Or to be more exact: What's missing in our photography?

Perhaps nothing.

We might be completely satisfied with it. Or, we might be frustrated - a little, perhaps a lot, that the pictures we make aren't quite as we want them. If so, why not? What reason do we attribute to this less than happy state of affairs? Is it a lack of knowledge: "If only I knew more about development…"? Or do we put it down to a shortfall of equipment: "That sharper, brighter lens would really make all the difference…"? What difference is that?

We could look at it another way.

If we were to turn that new lens on ourselves, what would we see with even greater clarity? Perhaps we might see that actually we do know enough, and perhaps more than we need in order to make the kind of photographs we aspire to. And, yes, perhaps we would also see that we already have enough equipment and perfectly adequate facilities to execute these masterpieces and many others, besides. Perhaps we just don't realise this, or maybe we are not willing to acknowledge these possibilities. If so, why not?

To date my most successful images have been made on the cheapest equipment that I possess: an old, out of alignment enlarger (it needs a wedge to keep the head parallel with the baseboard), and an ageing, meterless Nikon camera with basic lenses. And, just because I have written books on technique and creative practice, it doesn't mean that I know a lot, or that it is important to. This was made clear a while ago, after reading an article. It was obvious that the author knew much more than me, wrote better than me and seemed to have more fun with his photography than me. I considered jotting down some notes: the article contained useful information. But when I got to the end, I quickly changed my mind - I saw *my* name credited to the feature! I forgot that I had written it some years before. Had the time come to let go of it all and just get on with making pictures?

As Tatina Semprini of the Trevillion Picture Library says: "We encourage our photographers to create, create, create."

These experiences relating to equipment and knowledge got me thinking. Perhaps it was not what equipment I *had* or how much I *knew* that was important, but who I was *being* with them. And who was that? Was I someone who produced, produced, produced? Or was I someone else wanting to take notes? Did I need to read any more articles or books on photography - except perhaps one that encouraged me to question who I was being as a photographer? This is the theme of *What's Missing?* - discovering our photographic potential.

But let's be clear. The book provides no answers, other than those given by the participating photographers about themselves and their work. How could it? We need to ask ourselves the questions to hear them. And what questions are these? You'll find plenty. Some are clearly stated, others are implied. Some I have set out in this foreword. My suggestion is that if you are really committed to your photography, then you should join in with this process of enquiry. I have and I am continuing to be surprised by what I am finding out.

So, *What's Missing?* is about finding out, but not about techniques.

The idea is to discover what lead us into photography and to see, now, perhaps many years on, how we are getting on with it. For example, years of teaching on photographic workshops enabled me to see that it was who photographers were, and more specifically what their *intentions* were, that made the difference between them being just ordinary or great photographers - frustrated or self-expressed image makers.

What do I mean by intention? Think about the work of Elliot Erwitt; it seems clear to me that he likes to have *fun* with photography; it is his sense of *humour* that makes his pictures. Perhaps this playful intention generates his desire to make images. In which case, what is our intention? Is it to have fun?

When I asked the photographers participating in *What's Missing?* whether they laughed in the dark, how many do you think said yes? Did I? Do you?

To quote Tatina again: "Photography is a lifestyle, not a profession". What lifestyle is yours?

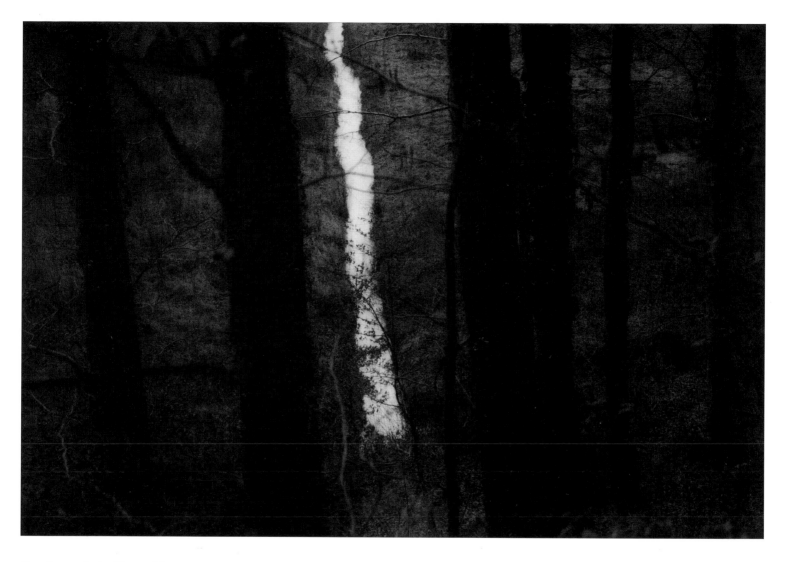

### Beech wood, the Cotswolds

*Sometimes I like to keep my landscape photography as simple as the process of going for a walk, for which my intention is just to enjoy. The objective is my chosen destination, and not to have made a certain number of pictures by the time I return. I do any rationalising later in the darkroom, as I reflect upon any images that I made while I was out. It is there I choose what to say with the negatives; it is there I decide if they are worth taking to the next stage*

*This print was made on Ilford ISO 3200, 35mm film and printed on their Warmtone Multigrade paper. A small amount of diffusion during the printing stage helped to suppress unwanted detail.*

## Choosing one's subjects

As someone who is interested in books and who loves visiting bookshops, I have always been fascinated by their cover illustrations, especially where photographs have been used. Over the last few years I had noticed some wonderful covers, using highly creative, often quite conceptual, but always inspiring pictures and plenty of them in black and white - my preferred medium. Many of these images were incredibly simple; they were the kind that would prompt many of us to remark: "Why, I could do that". I analysed the equipment and techniques that were used to make them and on the whole they were very straightforward. When I looked at the subject matter, what I saw was everday scenes, ordinary people and accessible locations: these were all available to me and to most other photographers. So who, or what, enabled these photographers to achieve success and get their work published?

Checking the credits to see who these image makers were, I was fascinated to discover that many of them came from the same source - the Trevillion Picture Library. I contacted the library and paid them a visit. I was inspired by what I discovered and by what I learnt about their photographers. It was a different philosophy that I detected. Intrigued, I invited a cross-section of their photographers to take part in this book, the basis for it being a questionnaire that I asked each of them to complete.

The questions I asked were structured in such a way that I hoped they wouldn't give the participants any sense of there being a right or wrong way of responding to them. The idea was simply to find out about who they were, in every sense of the word, and let their answers provide us with insights on what it was that enabled them to create publishable images. As you will discover, many of the photographers were up and coming. Quite a number were recently graduated, chosen by the library because of their fresh, unformulated views - as yet untainted by outside views of how things should be done or how images should look. As you read the book, I hope you will get a real sense of who they are and by asking yourself the questions they were asked, give yourself the opportunity to discover more about yourself and your photography.

Of course, I answered the questionnaire myself. I was surprised by much of what I wrote. Some of it was unexpected and very insightful, other parts were quite mundane, even depressingly predictable. In some of my replies I could see that I hadn't moved forwards for years, in others it was obvious that I had progressed a lot, but was this visible in my photography? Following is a selection of these questions and my replies.

## Some questions

I recently discovered that years of teaching, often facing large groups of people, asking them all sorts of questions about themselves, was actually my way of *not* being on the receiving end of this type of enquiry, or at least not in a fully engaged way.

All the time I was looking at these photographers, their images and their issues, and not at mine, although I always subconsciously brought this agenda of avoidance to each workshop without realising it. No wonder I decided to give up teaching until I addressed what was *really* going on in my photography. And if I look back over the images I have made, I can see that maybe many were about what was out there, rather than what was coming from within.

So, let's start by asking the obvious: *Who or what inspired me to become a photographer?*

On a subconscious level, who knows? Maybe it was the family slide shows we had every holidays. Also, looking back, I wonder if these were the time my family really explored its sense of identity. The photographs put a somewhat nomadic childhood into context. I hadn't realised this until just now.

*Of the photographs I have produced, which is my favourite?*

I have only included one of my images for this book, but of the ones published so far in *Creative Elements* and *Gradient Light*, I would choose Black Mount, Rannoch Moor as a reminder of what photography is about - or not about. The picture is of a solitary tree, on a remote little island. Looking at it, someone once described me as "a sad and lonely git!" Just recently I saw a similar image, in an old book with something of a spiritual theme. The light was the same, the location was similar, but there was no island and no tree. It was a picture of open space. It wouldn't have won any photography awards, but it was very peaceful and completely ego-less. It struck a chord; I loved it.

*What is my favourite photograph?*

It is an old black and white snapshot that a friend bought at a jumble sale for a penny or two. I assume it is someone's reject print. Slightly blurred, a telegraph pole is centre frame, while the subject, who is standing at the edge of the picture, is perfectly, yet accidentally cropped right down his middle. Wonderful. Everyone who sees it laughs. This discarded image says so much about photography, its rules and values.

*What is the difference between seeing and looking?*

I see with my camera and look with my printing.

*Am I a perfectionist?*

I am when I print, but not with the camera. I print with great attention to detail. It is this that gives my pictures their context.

*Who are my photographs for?*

The pleasure of making them is for me; viewing them is for everybody.

*Do I take holiday photographs?*

No, not usually. The concept of holiday photography is there to remind me to have fun with the medium all the time.

*Is there anything about the solitude of being a stills photographer that appeals to me?*

I was drawn to photography by its solitude. Hours on my own, on location or in the darkroom, allowed me to get very in touch with how I felt and I used photography to portray this, but - ultimately - what those images really showed was that I spent a lot of time on my own. So what? Now that I've seen this, I choose to spend a lot more of my time working creatively with others, as in my current book projects. I will always question anything whose motive implies that I should do it alone. I like to think how photography would be if it took two people (or more) to work the camera.

*Is photography about spontaneity or reflection?*

Working with a camera is about spontaneity; printing is about reflection.

*Photography: gift or graft?*

It is a gift I can present to myself whenever I choose. If it becomes a graft, I know that it's time to re-evaluate my motives.

*Technique: do I love it or hate it?*

It loves me. I can do it; IT knows this and it sticks to me like a leech. I constantly remind myself not to feed its desire. I'll use it - when I choose.

*Does the camera open up my view of the world or frame/contain it?*

The camera explores my view of the world. I use printing to frame it, but never - I hope - contain it. I like the idea of pictures setting their subject free, rather than trapping them like butterflies in a frame.

*Do I work to a routine?*

I'd like to think that my routine is curiosity. But often I get too significant about making images, imposing values on them before they have a chance to reveal what they can teach me, which is often about letting go.

*Do I ever laugh in the dark?*

Not usually. I always saw the darkroom as a contemplative place: a meditative space, suited to reflection. But, now that you ask, why can't laughter be contemplative? It's an interesting thought. This just goes to show what you don't know until you look: keep the questions coming.

*Do I work to a system?*

Yes. I always try to separate the event leading up to the moment of camera exposure from the print, often waiting weeks or months before I enlarge the negatives. By this time the memory of the event will have faded and I will be able to see the image for what it is.

*What determines a well balanced print?*

It looks right; it looks easy to make; it's not overstated; intent is clearly visible; it looks complete. It just IS. Ask me again tomorrow and then the next day and I'll probably keep saying something different. I guess a well balanced print is one that clearly states its intention and this might change from picture to picture.

*At what point am I satisfied with a print?*

When it can take me places. I like to sit back in the darkroom, away from the print, view it on the splashback, be taken back to where and when it came from, and also be taken somewhere else, quite magical. That's when I know it works.

*How long might it take to make a print?*

It could be months: the making doesn't just happen in the printing; it occurs in the build-up as well, and in everything that happens during that time. This gradual process of development is as important as any darkroom technique. In respect of making the final print, typically I spend a day working on one negative, producing off it - at most - three or four toned 20x16" prints.

*Describe my darkroom equipment.*

The darkroom itself is the key. It is a converted 16' caravan, sitting in a friend's hillside garden in the Cotswolds, situated between their darkroom, a light studio and a sculpture studio. Being 'outdoors' gives it something else: I can hear the wind and rain, the birds and voices, and when I open the shutters there is a wonderful view across a small valley to a beech wood. With this I consider I am well equipped to print. No amount of fancy equipment could impact my printing in the same way. As darkrooms go (and I have made plenty of them) it is the simplest, the cheapest and by far the best. I could never go back to working in 'dark holes'. It is amazing how much they affect one's approach to printing.

*What is a photograph to me?*

A photograph is an invitation to discover. How does the saying go? - art resides in interpretation and in reinterpretation. A photograph is a beginning. Once framed, a print is not an end.

*What has been the most valuable photographic criticism I have received?*

A trusted friend once said my medium was *words*!

## An ongoing enquiry

The twenty three photographers from the Trevillion Picture Library who I invited to participate in this book were asked a wide variety of questions. As you will see from the portfolio sections, the questions were roughly divided into three groups.

i) their background and who or what inspired them to become a photographer,

ii) their relationship with photographic technique and the techniques that they employed, and

iii) their thoughts and insights on photography.

Remember, the point of these questions isn't to get us to change our views, but simply to realise more fully what they are. The more we know about what motivates us and also what stops us (if anything) from making great images, the better.

Below, I have selected one quote from each photographer, as an introduction to the book. Each raises issues about what it takes to be a successful photographer. Some of these were new to me, others were quite familiar. All of them are part of the ongoing enquiry into what it means to be a photographer.

One thing, in particular, that struck me about the replies was the humour and the sense of playfulness that they showed, even though few photographers responded positively to the question about whether they laughed in the dark. I suspect that where humour exists, much of it is innate. I would also suggest that it greatly affects the way that individuals approach their work and, inevitably, it reflects upon how their images look and the way in which they are perceived by the viewer. 'Serious' photographers are unlikely to raise the spirits of those who view their images.

## Our views on photography

Against the following photographers' quotes I have noted some issues they raised for me. I have given my views on them. My ideas may be quite different from yours. *Great.*

Lesley Aggar

*"What else do I do? My very best!"*

This reply (and the book) are an invitation to address one's level of commitment to our photography. Therefore, I ask myself how easily do I give up? Or, maybe my photography is always an act of will, a matter of ego, in which I never give up - no matter what. Is this creativity? Isn't photography concerned with setting free one's views and committing these to film, then to paper?

Annabel Baker

*"I can't understand the attraction to principles like 'The Zone System'. I wouldn't end up having any fun and it's important to enjoy what you do."*

Here, I am inclined to question the level of satisfaction we get from our photography and - even more importantly - the degree of satisfaction we *expect* from it. All too often I'm very focused on the end result - getting a great print, rather than the amount of fun I can have in all the processes that contribute towards making it.

Allan Baxter

*"If the camera contains your view of the world you're using it wrongly."*

What this makes me more aware of is that the photographer is always more important than the camera.

Alun Callender

*"I usually give my snappy camera to someone else when we are all out, so I can appear in the photos and know that I exist."*

It is good to hear from at least one photographer who is willing to put themselves in front of the camera lens. That said, don't all pictures reveal the photographer's identity and say a lot about them?

Andrew Cockayne

*"Best criticism? When one of my course tutors at college told me I hadn't really lived up to my potential and I probably wouldn't amount to much!"*

Honesty and perseverance obviously count for a lot. Following on from what I said previously, I would suggest that there is a big difference between persevering with one's photography as opposed to making it an act of will.

Andrew Davis

*"Best critics are my flatmates, who always see the prints in the bath."*

Who is the best judge of our work? I have often found the best criticism comes from non-photographers. They tend not to look at how sharp the print is, or how enviable its tonal separation might be. Instead, they see it for what it is and judge it accordingly.

McVirn Etienne

*"I'm satisfied with a print when I don't need to compare it with a previous one I've made."*

I like the idea that we should always be recreating, discovering new ways of expressing ourselves, but without resorting to new techniques. In this way we are always going from zero, creating from nothing, ie working from a fresh palette rather than, perhaps, repeating previous themes?

Roderick Field

*"A photograph is a short story. A good photograph is a poem."*

In what way does a photograph speak? Or does it?

David Gibson

"What is a photograph for? There are many answers to this: confirmation that we are all really the same and that sometimes we look rather odd."

Photography is as much a reflection of our subjects as it is of ourselves. I would say that making photographs is an invitation to look at ourselves from the outside.

Jon Hatfull

"Looking involves the eyes. Seeing? The mind."

How do we interpret the subject and the print? From the photographers' replies, it is clear that looking and seeing are very different processes; for each person they mean something quite different. How then can we expect to develop our vision, which is necessary to be a successful photographer, without first asking ourselves this type of question?

Darlaine Honey

"Best criticism is 'You don't listen!'"

As photographers we require a sensitivity to what's around us and that includes other people. Also, when I think about the number of photographers I've met who've said they don't get enough feedback (myself included) I wonder how often we ask for it and, if we do, how well do we listen to it?

Stuart Knowles

"Is there anything about the solitude of stills photography that appeals to me? Yes - and that's why I only choose to do it part-time. The solitude gives me the opportunity to put more of myself into my pictures. However, at the end of the day we need to get a life!"

Without balance, the process of seeing might become very introspective. And just how healthy would this be? What kind of a life do we want?

Richard Lewis

"What does the phrase 'photo heaven' conjure up? Hell! Lots of photographers. Hell!"

What is it about photographers?!

Alexandra Murphy

"At times I simply don't wish to carry a camera around as it bears its own 'weight' and responsibility."

Stay on track. Photography can easily become a burdon and a responsibility, rather than a freedom: I know many photographers who can't go anywhere without a camera. Is this need obsessive?

Joseph Ortenzi

"I have to limit my choices otherwise I am constantly working out the differences."

Clarity has to come from within, not from technology. There is rarely a time when I have the ideal combination of equipment and materials, but the challenge this presents is what's important.

Dean Rogers

"Best critic is myself, as I do expect to get the best out of my work."

What standards do we work to? Who or what has established these? Identifying one's own standards is an important part of the photographic process. It helps us to identify our aspirations and therefore to deal with the question of choice, raised above.

Alice Rosenbaum

"What determines whether I like a photograph? The indefinable thing...whether it affects me."

What makes a great image is subjective. Just how easily are we swayed by the opinions of our peers?

Dario Rumbo

"...when by mistake I get a unique print, then I am happy too. These prints haven't got the Ansel Adams quality but they are 'perfect' and unique in their own right."

Photography is an ongoing process of discovery. If we compare our work against that of others, what will we achieve?

Philip Thomas

"What determines whether I like or dislike a photograph? There's one simple test, does it change your life?"

How many of our images say something new? Of what do they speak, if at all?

Michael Trevillion

"What can people see of me in my work? Not much, perhaps a longing to be a fish."

Our photographs speak, both about us and our subjects.

Brian Wells

"What do people see of me in my photography? That I am artistic and a bit of a loner; curious I would think."

Where's our passion? Can we make photographs without it?

David Woolfall

"Photography's egalitarianism is its beauty."

It is important to remember that, even though we may work alone, we are not separate. We all belong, and the fact that photography is available to everyone, demonstrates this.

## What else can I say?

How well *What's Missing?* helps us realise our potential depends on how willing we are to engage in its process of enquiry. Just how committed are we to putting ourselves in the picture?

It's time to let the photographers, then the rest of us speak.

# Lesley Aggar

**Status** Part-time professional.

**What** else do I do? My very best! Outside of photography I distress and paint old furniture, and I colour wash walls etc. Also, I love to concoct delicious meals and listen to music.

**Inspired** to become a photographer by my mother's Kodak Instamatic, which I used from the age of twelve. Yes, photography is a passion.

**Learnt** by trial and error to begin with, as I couldn't get my brain around apertures. Then I lived in Sydney for two years and spent one year studying at the Australian Centre for Photography.

**Who** would I like to learn from? That's really hard; there are so many talented photographers in different areas whom I admire, who are alive, and lots that are dead!

**Favourite** photographer is Andre Kertez. My favourite photograph is a very simple interiors shot (the title escapes me) made in 1926. It has a great sense of mystery, but also one can sense a presence seeing the tulips on the table.

**Best** critic is photographers who I respect and admire. As for best criticism, that's a hard one to answer. I've either lost my memory completely or I didn't dare to listen. Other peoples' opinions are valuable as long as they are honest.

**Aspiration** is to be the best I possibly can.

### Techniques

I am not a technical person - I am more instinctive. It took forever to get to grips with technique. I would say I am now competent, although studio situations are still my least favourite. I believe we all have to learn the rules before we can break them; left unchallenged they can stifle creativity.

### Camera work

The camera frames a small portion of the big picture leaving the rest to the viewer's imagination. I do pre-visualise my photographs if they involve people, but only the outline, as I like images to evolve naturally where possible. Do I have a routine? No, I get bored easily and prefer to be spontaneous.

Equipment: Nikon F90X, 28-70mm and 70-300mm zooms, plus flash. Mostly I use aperture priority and spot metering mode, also I bracket. I avoid a tripod where possible with black and white, preferring fast film. I also have a Hassleblad 500c, with 50mm and 150mm lenses, and backs etc. I do use the tripod, otherwise I'd be fired. I have Courteney studio flash. Finally the 'snappy' Olympus mju:zoom - compose and press. I always carry a camera except out socially. Woops, that's a lie! I carry the snappy.

### Darkroom work

I don't work to any particular system. I choose the negative with the most overall density, which will hopefully be easy to enlarge. I normally print 12x16" at f5.6, with a basic exposure of 20 seconds, then I make the test-strip with +4 second increments. A print is balanced when the edges are equally printed to keep the image in place; this helps to keep the viewer's attention within the frame. After all the hard work of burning and dodging, the print must look naturally created.

How long might it take to make a print? The larger the print the longer it takes. I'd say it takes from half a day to two days if it's to be toned. I am satisfied with a print when I feel I cannot improve it.

Equipment: De Vere 203 cold cathode enlarger. Note book. Black cat stop clock and foot pedal. Beard easel. Most important - RADIO! Numerous bottles of toners, developers and even bromoil inks etc, but I'm told I need to be ninety before I try that one!

Do I ever laugh in the dark? Yes, when printing with a girlfriend or when winding up a certain photographer who was trying to teach at a Spanish workshop. Great fun!

### Post darkroom work

Apart from toning and split toning, I sometimes hand-tint specific parts of an image with water-based dyes.

I don't use computers yet.

Equipment: Spotone and water-based dyes for hand-tinting. Scalpel and cotton wool for cuts and bruises, having attacked the print with frustration.

Am I a perfectionist? Yes, I like to think so.

*Photography is about spontaneity and reflection. I find that ideas are spontaneous but quite often I have to reflect on them and return to get the picture right or to see something different.*

*To be a gifted photographer is one thing, but to be noticed and recognised is another. That is the graft for most photographers.*

*Is there a difference between seeing and looking? Yes. Seeing is to notice the detail, to consider what is there. But it is also a mental experience of seeing beyond. Looking is to search and to hope to find it?*

**Andalucia - Spain**

*A non-commissioned image, inspired by the light and the simple remains.*
*Printed on Polywarmtone RC. It was diffused in printing. The top left corner and foreground rubble needed burning-in.*

Aggar - 2

13

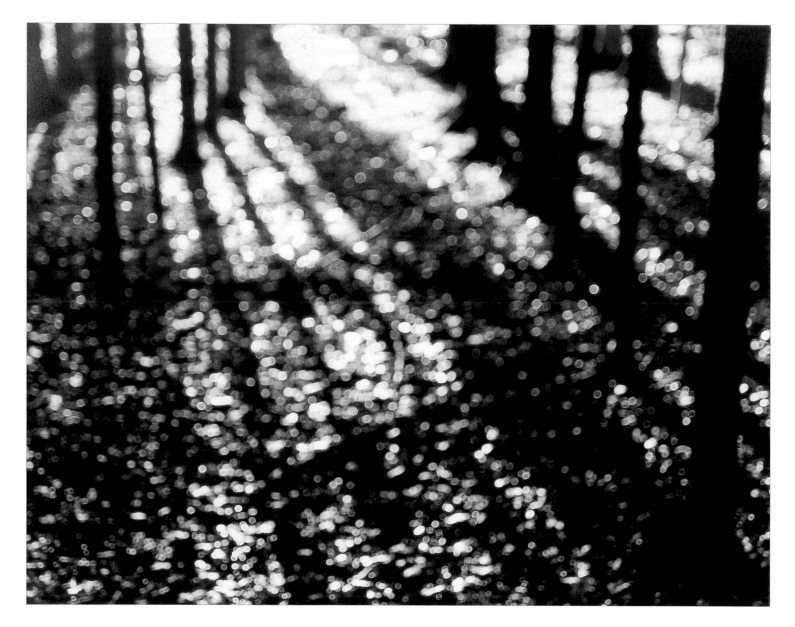

**Pattie's Copse**

*Taken with frozen fingers and I couldn't focus. I'm lying again! The effect was deliberate. I liked the pattern made by the light and the fact the viewer has to think about what it is.*

My imagination is vivid but my biggest problem is remembering all the images that constantly come into my mind.

Apart from sight, feeling is my other most important sense.

14

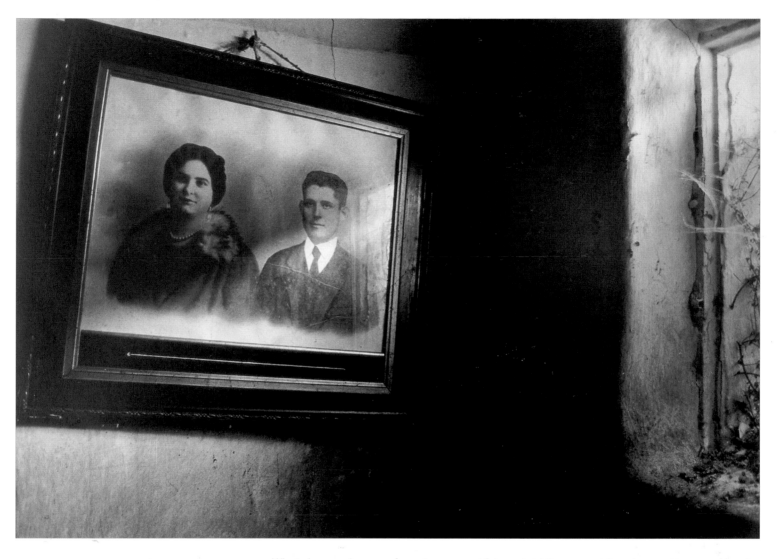

**Andalucia - Spain**

*A non-commissioned image, inspired by the light
cast upon this nostalgic image.*

*What do people see of me in my work? I am told "an unusual and sometimes quirky (I
like that word) approach".*

*I like a picture to tell only part of the story, so I'm left wondering. If it's blatantly
obvious it has no mystery.*

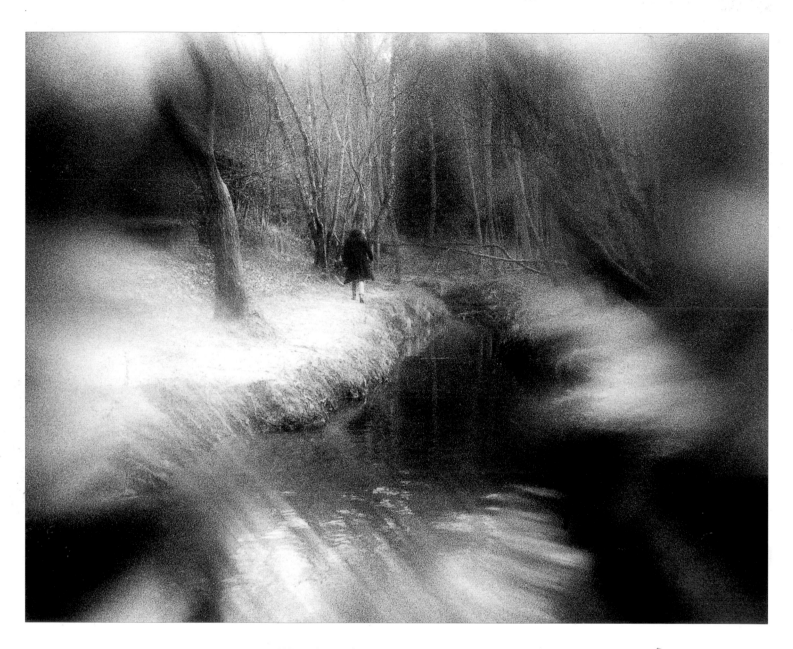

**Ashdown Forest**

*A personal image, but made with the picture library
in mind - they needed forest shots.
Printed on Ilford Multigrade RC.
I put Vaseline on the camera filter, slightly diffused
the image in printing, plus I burned in the corners. It
was lightly sepia-toned. Yes, I like the image.*

*Which is my favourite photograph? The derelict room in Andalucia because it's
evocative of time past. It leaves me wondering who lived there and who they were. I
love questions unanswered - mysteries.*

16

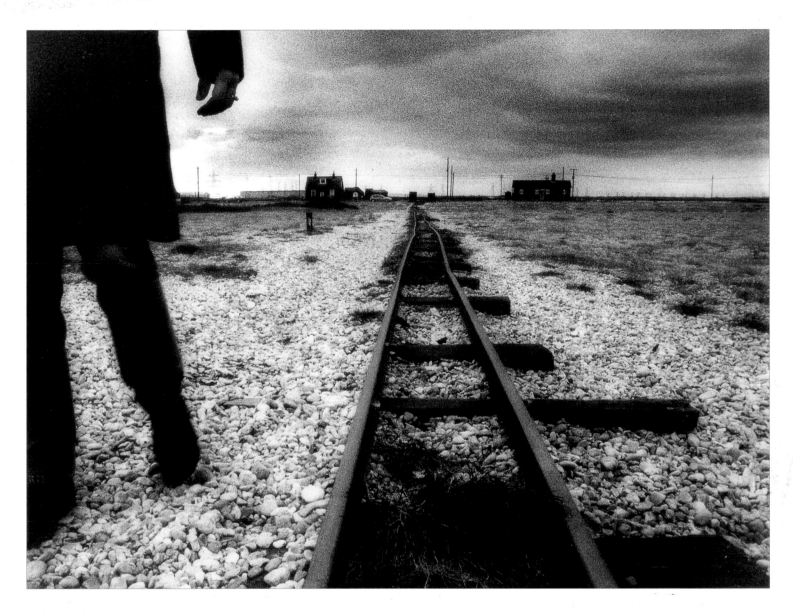

**Dungeness**

*This is one of a series of pictures taken in Dungeness, inspired by the surreal landscape. Shot on Ilford 3200 film and printed on grade three.*

My idea of photo heaven is an endless supply of film and materials, and spending time with inspiring individuals.

# Annabel Baker

**Status** Professional. I work on a freelance basis with no second income at this time.

**What** else do I do? I like to dabble in interior design and decrationg, also collage using mixed media - although not as often as I would like.

**Learnt** at college. The most significant times were on Foundation course at Loughborough, where I had massive opportunities to experiment and have fun with a wide range of media, and on my degree course at Blackpool College where my technique and style became refined over three years. Today, I'm still learning all the time.

**Who** would I like to learn from? There are so many artists, photographers etc whom I admire. It's difficult... I would like to have been educated at the Bauhaus school of design - Laslo Moholy Nagy, Kandinsky etc.

**Favourite** photographer? I have many 'favourites' - among them: Alexander Rodchenko, John Deakin, Eilen Von Unwerth, and the painter Gerhard Richter. My favourite photograph is an old Poly photo of my mother as a child, which I have framed on the wall of my studio. For sentimental reasons, I love this picture. My mother is deceased, but also the fact that my grandfather gave me the picture means it is dear to me. He is a very good friend of mine.

**Best** critic? Recently I was told by a designer I know, that two years after leaving college my work appears more 'considered'. How much I value criticism depends on whether I value the person giving the opinion; those who I respect and whose work I admire I probably value more so.

**Aspiration** is to earn a living from doing what I enjoy - taking photos.

## Techniques

Technique, as in the text book style? I hate it. and the idea that a print should be a certain way. I can't understand the attraction to principles like 'The Zone System'. I wouldn't end up having any fun and it's important to enjoy what we do. I love experimenting, doing what we're not really supposed to. My rules are that there are no rules! Mistakes? - don't make them twice.

## Camera work

Do I pre-visualise? Not necessarily, as when I am commissioned I am not always familiar with the person/subject. However, with a tight brief, I will have a fairly good idea how the final shot may look, so I'll sketch the idea on paper and it may determine what kit I take on the shoot i.e. diffusion materials, glass sheet, vaseline etc. I always carry a camera, more often than not two or three different cameras. Equipment: Pentax 6x7 outfit/tripod, 2 x SLR's, and a 35mm automatic. I have no set routines as such. I like to experiment. Techniques: sandwiching transparencies and double exposures, hand-painting prints with various materials, toning prints and bleaching etc.

## Darkroom work

I would say my darkroom methods and practices are pretty standard, although I like to experiment in the darkroom also. How do I choose which negative to print? Looking, looking again - close-up with a loop. Normally something just clicks and I know which ones to print. There's an image that jumps out at me. Other than that, it depends if I have a brief - my selection is then bound by a specific idea. Equipment: a card with a hole in for burning-in, dodgers of various sizes for holding back, tracing paper for diffusion held under the lens, diffusion filters used occasionally, various pieces of glass, broken and cracked for through-printing on the baseboard, vaseline to put on the glass to play down certain areas for printing through and ink smeared into cracks on glass sometimes.
Laugh in the dark? Yes, but then I used to print alongside friends at college. I don't do as much darkroom work now as I did.

## Post darkroom work

Bleaching, toning, hand-painting, drawing, working on the print, oil pastels; overlaying transparencies; techniques of layering, mixed media - I did use household products a lot, and unconventional media. I have used Photoshop occasionally for commissioned work, but only when absolutely necessary. I prefer other methods and only use the computer for simple tasks i.e cutting out backgrounds. Sometimes I will output digital prints - I will laser copy these and then at times the laser copy can be considered my final printed copy.

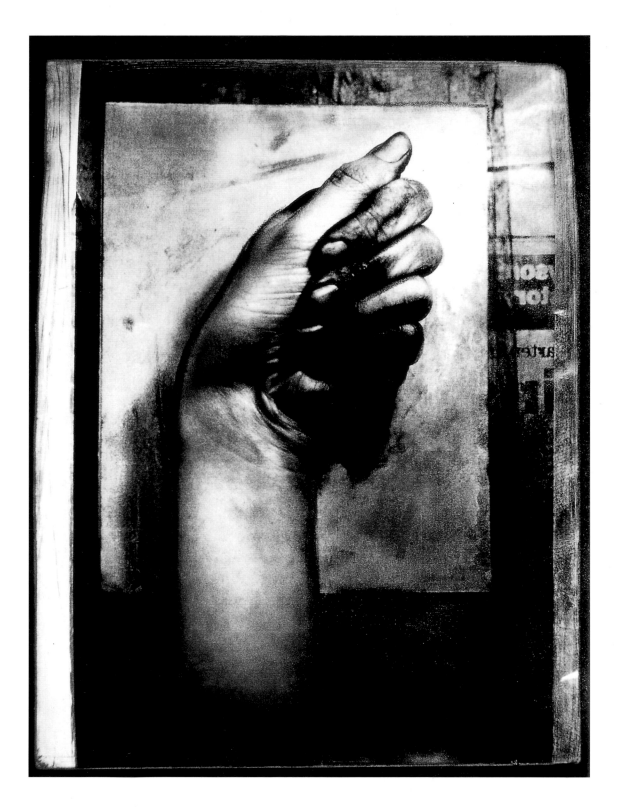

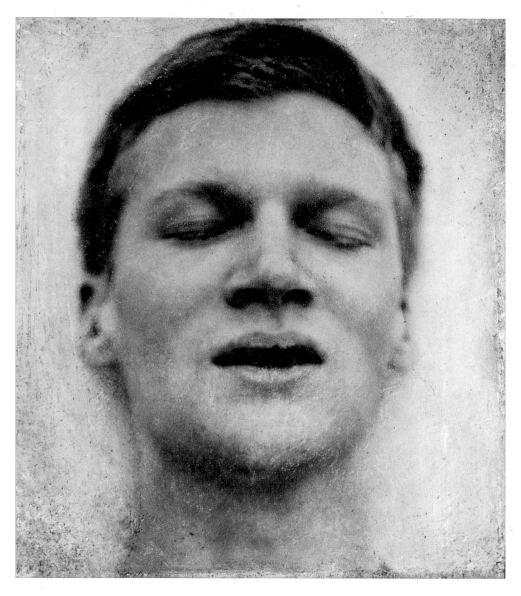

previous page:
## Hands
*Part of a triptych. A personal photograph.
I was just about to wash my lead-stained hands and I thought how beautiful they looked. A spontaneous image.
Printed on Ilford FB paper.
The picture was shot from above, with newspaper underneath. After printing, the image was worked on with oil pastels and gouache.*

this page:
## Matthew 1
*A personal image, done at college. I wanted to photograph exhaustion. Matthew ran up and down Blackpool beach until he couldn't run anymore. Meanwhile I waited with the camera - he ran in and I got the shot. Printed on Agfa matt FB paper. I then worked on the image with oil pastels to accentuate certain areas and to play down others. Exhaustion seems to have recorded itself as death. Virtually every client has called it a 'death mask'. I understand what they mean. I think the image itself is strong and yet very peaceful.*

opposite page:
## Belly Buttons
*Construction plays an important part within my images. By introducing various mixed media, I can bring another dimension to the image.*

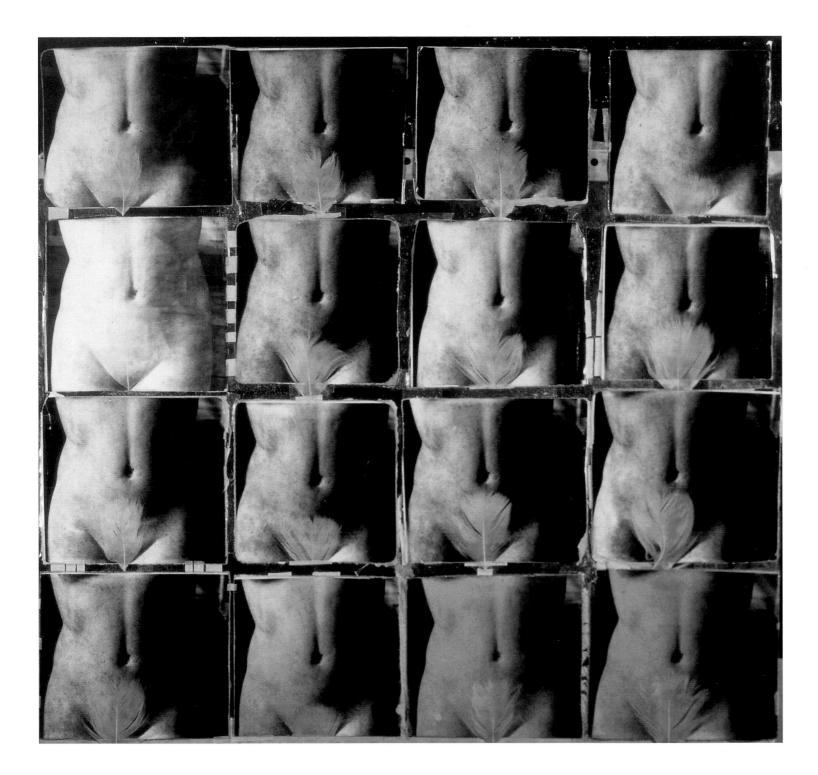

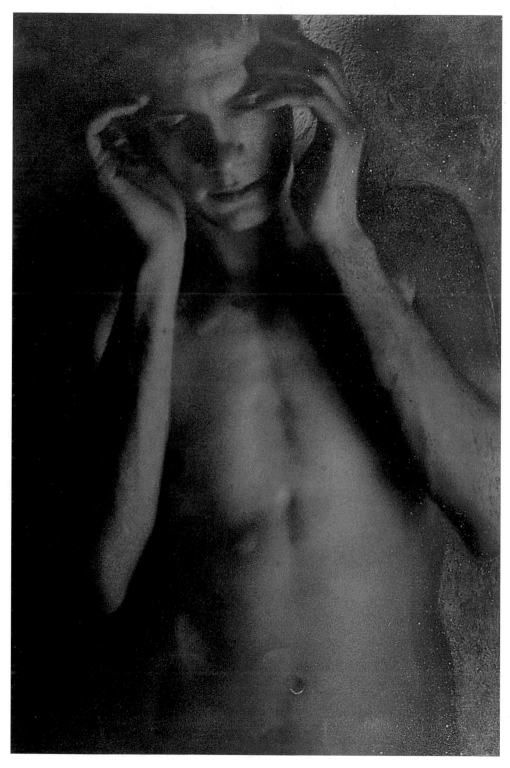

*The subject matter has to interest me, so does the overall 'feel' of the print, composition and its treatment.*

*My favourite image is probably not the most successful in terms of how I originally expected it to look on completion. I mean, it ended up looking very different - but I don't really think this matters.*

*I'd like to do an extensive portrait study of boxers - beaten up and battered, and maybe a book of my work someday.*

*Photographs, whether personal or commissioned, are reminders.*

**Male nude study**

*What role does imagination play? Sometimes an awful lot, sometimes very little. My imagination can at times inspire me and I'll get very excited. It depends upon what's happening to me at the time I guess?*

*At the time when I created the prints chosen for this book I guess I was interested in subtlety and also beauty. Now I feel my work is more graphic and bold. It's important to move a book of work forward. I wouldn't ever like my work to become repetitive.*

*Usually I spend an hour or so on a print. Sometimes I may not achieve success after a day spent in the darkroom - very frustrating.*

*My camera enables me to see the world in a different way. I can be selective and specific as to what I choose to photograph.*

**Tom Need**

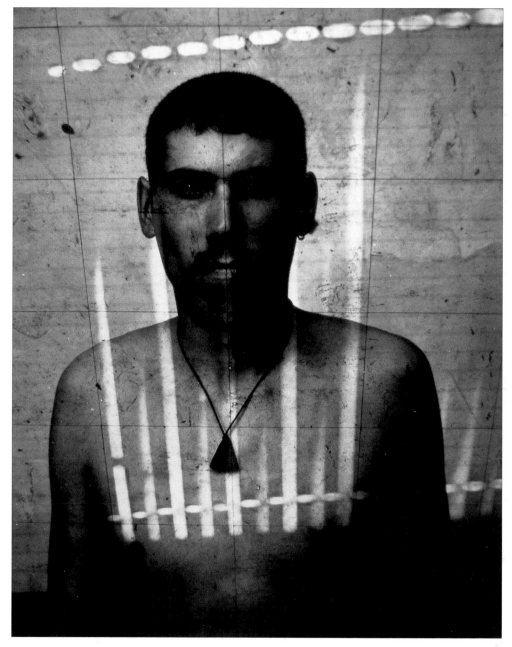

*The overall treatment of the print should be 'sensitive' to the subject matter.*

# Allan Baxter

**Status** Professional, also assisting.

**What** else do I do? I travel extensively and scuba-dive. New 'worlds' stimulate a greater interest and coherence in understanding one's own background and culture.

**Inspired** to become a photographer when I saw "Blow Up" as a lanky, awkward teenager and wanted to be the David Hemmings i.e. the Bailey character. I'm sure the myth of being David Bailey is far more prominent in starting photographer's careers than many of us would like to believe.

**Learnt** at school. Later from photographers, college and mistakes; the assimilation of knowledge is an on-going process.

**Who** would I like to learn from? Someone such as David Carson or Vaughan Oliver who, as graphic designers, bring a radically different perception to the visual communication process. I know that Carson teaches and his philosophy is to help students find their own voice. Isn't that the essence of any creative industry?

**Favourite** photographer is William Klein. Favourite image? Richard Avedon's 'Killer Joe Shapiro' has the rush of something awesome. To see it up in an exhibition is really quite frightening, more so than, say, Witkin's headless portraits

**Best** critic? It's the creative and art directors I meet in London. A few have a real coherence and comprehension of visual communication. Best criticism is 'Learn to dance as if nobody is watching you'. It's stuck with me.

**Aspiration** is just to continue to make a living that involves me developing as a photographer and an individual.

### Technique

It should really be a positive element to communication and treated as such; a photographer's vocabulary of sorts. Of course it's frustrating when things go pear-shaped, but then who said it should be easy?

### Camera work

The camera is an exploratory tool. It opens new ways of viewing - lie on some grass, with the camera on the ground, gaze through the viewfinder and move the focusing ring. You're in a continual process of searching through different worlds. If the camera contains your world you're using it wrongly.

Technique-wise I experiment with different planes of focus and use movement through varying shutter speeds, I also abuse UV and polarising filters with all sorts of substances. I re-photograph images with text, montage different prints and slides next to each other, tone bleach and scratch both colour and black and white images and attach different gels to flash-guns - virtually anything to get the result. Equipment: Sinar Norma, Mamiya RB, a pair of old Nikons and a £4 Halina panoramic fun camera, together with a small Metz flashgun and a Benbo tripod. Do I always carry a camera? Not always. I find that the possibility of not shooting helps perceive a wider view; in many ways a notepad and pen is more important. I also find myself in areas where mugging is a serious danger.

### Darkroom work

I usually complete a series of test-strips (some split-graded) then attack them with a hair-dryer until bone dry; wet test-strips can be misleading. I then assess the test-strips to the original contact and my diary, before assessing which direction to take. My exposure methods include Sabattier, flashing and split-grade printing.

What determines a well balanced print is intuitive. Assess Klein's classic 'New York 1956-57' book with Ansel Adams' theory on exposure: at best it's amateurish.

Rules? Keep in mind what you are trying to say with a print and work accordingly. I am satisfied with a print when it says what I want it to say.

Prints take from half an hour to four hours. Toning or lith add an extra three to six hours.

Equipment: I belong to Camerawork, a community darkroom in London. It has Bezler and Durst diffuser enlargers. Two are necessary for Sabattier and flashing. Do I ever laugh in the dark? As long as deadlines aren't looming I'd like to think of the darkroom as a playpen.

### Post darkoom work

I retouch with Spotone inks, and use a Powermac system with Photoshop 5. With a great deal of help I'm currently computer manipulating my first serious work on Photoshop, changing colour curves and the size of pixels etc.

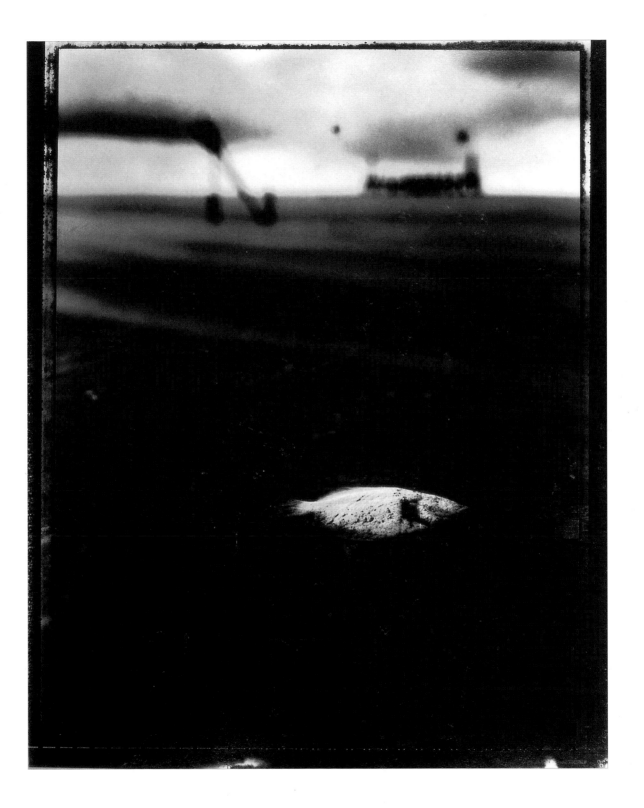

Any lecturer can teach you how to use a light meter, but there are individual teachers who have the ability to get inside your head, to identify and motivate your unique personal vision. Their input is priceless.

Professionally, I started as a b&w printer and processor in London, which put some reality into the situation. After two years in the dark and much encouragement from people in the industry, I believed that I could at least be as professional and creative as many of the people I was working for. Even talking to musicians and poets I knew made me feel that I had creative aspirations that were becoming quite polarised.

As a series, Ernst Haas' 1956 bullfight images capture a vibrant beauty of movement, unparalleled without straying from the essence of the event. Criticism is vital to the development of any artist. When we're inside, it's difficult to remain independent - alike to being critical of your children, afterall you've nurtured them. If no-one else understands our work, maybe we should ask exactly what it's for. Perhaps the greatest skill is deciphering how valid a peace of criticism is, and that again goes back to intuition.

Already this year I've been privileged enough to work and assist in China, Hong Kong, the Maldives and New England. Photography truly is the best vocation I can imagine.

The only rule I'd adhere to would be 'try to maintain myself within whatever I do'.

Mistakes, especially when taking risks, if we're aware, can teach us to discover our own direction. I'd be stunned if Dick Fosbury high-jumped two metres when he first leaped backwards.

I remember when I was first at college and we were sent out to photograph anything. It was strangely difficult and far too open. For me, personally, what's needed is a simple brief, just a couple of words about what I'm aiming for when shooting. However, to visualise the finished image exactly when I shoot it, undermines the whole shooting process.

I tend to have a source-bank of images, textures, videos and quotes, that I'd use to find a solution if I became stuck. This is a personalised route-map, that directs me into the kind of image I'm aiming for. I also use an elaborate diary, which I use for tests and the like. I always refer to this before going shooting, as it helps me build from previous shoots.

My favourite image is 'The Flounder'. I'm engaged by the graphic but vaporous/flowing quality that separates the fish from the background. The effect of the Polaroid and the split from the toner really enhances the brief I was given. Ultimately, it still intrigues me. I was also extremely surprised it worked so well as the actual shot was taken under the most appalling conditions of icy winds on a Northern beach in February, fingers going purple, whilst fiddling with lenses, and sand attacking my camera etc.

previous page:
**The Flounder**

A commissioned work. It's based upon the Gunter Grass novel of the same name.
I see it as organic and delicate, within a featureless environment.
The negative was made on Polaroid Type 55 pos-neg. It was printed on Forte FB paper, bleached and selenium-toned.
The photograph seems old but not nostalgic. There is an eerie, last man on earth feel to it. It reminds me of an area in the Antartic where no snow settles but freezing temperatures keep dead animals in pristine condition for hundreds of years..

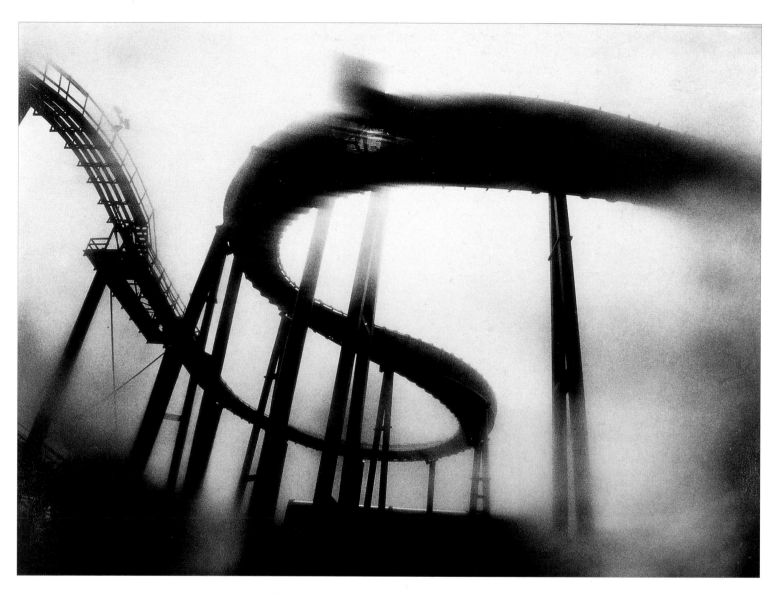

### The Avalanche

*A personal image, illustrating the speed and fear of the first drop of a rollercoaster ride.*

*Forte FB paper. It was shot with a Mamiya RB 67 camera with a smeared lens looking into the sun. The print was slightly bleached and then selenium-toned.*

*It still works through the shape and pulsing quality without any real form. It's the only print I've done that keeps its sparkle, even in reproduction.*

*I tend to view the contacts through a lupe, choose 3 to 6 possible choices and crops, then, if possible, try to get some distance from the contact; at this stage alternative opinion is helpful. I will then look later, maybe with a friend, to finally decide what really works. If the shoot is of more importance, I'll make a few gash prints, especially if it's a series of images.*

*The printer should play second fiddle to the photographer not vice-versa. In many of the best pictures ever exhibited one doesn't even notice the printing.*

'Camerawork' - the community darkroom I use, is also a good place to network with photographers in similar situations.

Whilst printing, I find that a pair of dodging tools, an A4 sheet with shapes cut out, a black stocking and diffuser filter are more than adequate in the vast majority of situations. Separate trays, solely for toning and especially lith printing, are also essential to avoid contamination. The best advice would be 'really try to keep things as simple as possible'.

I become uncomfortable with my imagery/work when I've compromised in an attempt to make others happy; the result is invariably bland or cliched. Photographers who endlessly turn out the same technique or photograph, no matter what the subject, also deflate me.

I feel that the mainstream photography world has, to an extent, categorised what should be considered worthy photographic material. This has led to the same lake and mountains being continually shot by technically proficient photographers, turning the scene into photographic muzak. There's even a 'Shell' guide that tells you how, where and when you should photograph the landscape. Where is the sense of discovery in that?

Duane Michals said that when photographing, 'Each person should be a different solution. The photographer should approach each sitting as if he had never taken a portrait before. He should be surprised by what he's done.' I believe the same philosophy is valid in all photography.

Apart from sight, touch is my most important sense - not just physical objects, but feeling the natural ambience/resonance/aura of a location or being.

Looking is passive, where everything's just there for us without mystery, akin to gazing at the T.V. Seeing should be exploratory, active and selective, demanding us to be wide- awake.

There has to be a cut-off point to make life bearable. I'm not sure that perfection is really a valid notion.

Unless working on a job, I intend photography to push myself forward.

I do take holiday/fun photographs. They even overlap into my folio work. As they are more intuitive, fun images can reveal more of oneself than thought-out imagery. I'd like to think that all my work involves some sense of fun, chance or accident.

Working ideas through with art directors, models, printers etc. can be one of the most rewarding aspects of photography. The very process of explaining ideas can focus them inside.

opposite page:
**Malay Fish Head**
A non-commissioned photograph, shot on 35mm Tri-X using available light only. It was printed on Portriga Rapid and split-toned with selenium and gold toners.
It's really a holiday snap that came to my attention when searching through contacts. When shot, it imbued a sense of surrealism having this bulbous face hanging effortlessly before me. It was taken on my first trip to South East Asia with my then girlfriend. It always evokes memories of constant stares I received when we arrived in her home village, with me being 6ft 2" and with fair hair. On reflection, the images always strikes me as a dejected alien.

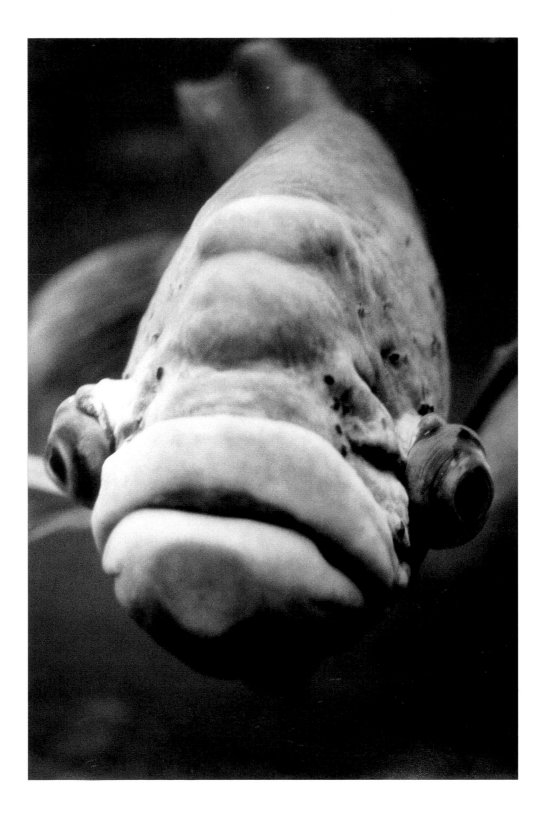

For me, photography is at once spontaneous and reflective without contradicting itself. The media is physically spontaneous but what one strives for is reflective of one's existence. I'm not an advocate of art for art's sake.

In China, I intuitively took a series of masses of Koi carp in a feeding frenzy. Later I could equate this heaving, distorted, confused mass of oranges, reds and yellows with the scene that I viewed walking into Gangzhou at rush hour. This was not pre-determined - it just felt correct at that moment.

Photography: gift or graft? Gift is perhaps too abstract a concept, certainly a voracious appetite to express has to over-ride the graft. An activity as difficult and sometimes traumatic as this would be unbearable if I doubted the validity to achieve results that at least have the potential to challenge and stimulate.

Akin to printing, computer manipulation won't make an unsound idea work; polished crap is just crap that's shiny. However, used properly, it opens up many directions especially with E6 slide film.

What do people see of me in my work? I'd like to think someone who's unsettled and restless but also persistent and determined.

I feel that many student shows/exhibitions seem to have the heavy resonance of misery attached to them, as it is more relevant than any other emotion. A possible reason for this is that students are often asked to immerse themselves within quite complex theory at early stages. This, I feel, can counteract the sense of enigma and creative atmosphere necessary for producing innovative imagery. I'm not suggesting courses should be dumbed down; there has to be thought processes at work. It's just that the childlike sense of 'Wow' is surely of equal importance.

Honestly, I'd hope that after some basic training, painting or music could fulfil the same purpose as a means of expression as photography.

Photo heaven would be to own and work in Margaret Bourke-White's old studio at the top of the Chrysler building in New York without the pressures of rent/mortgage of course.

A photographic wish is that clients/agencies gave jobs to photographers solely on originality and talent.

Without curiosity and imagination I'd rather give up.

opposite page:
**Opuntia Invictus**
A personal photograph. Its Latin name means to inflict pain. I tried to illustrate this through photography.
It was shot on Polaroid Type 55 pos-neg with a single redhead light and reflector, for narrow depth of field - to emphasise the spikes.
Forte FB paper with a slight selenium tone. The print was split-graded to increase shadow density.

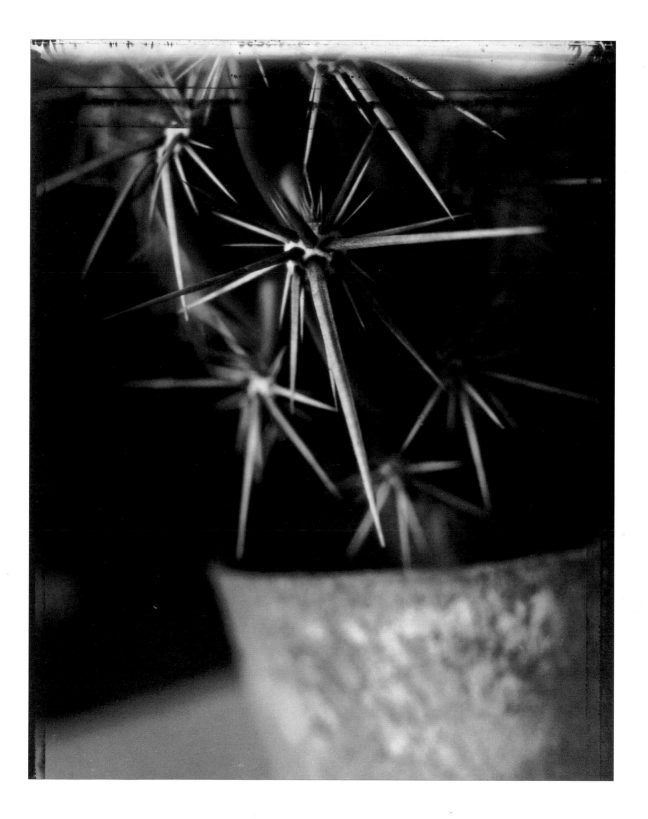

# Ciara Bedingfield

**Status** Full time artist and part-time professional photographer.

**What** else do I do? I teach various fine-art photo classes. I volunteer at Visual Aid (an organisation helping artists with life-threatening diseases). I will take any paid job when I get desperate (within reason!).

**Inspired** by being politically and socially aware when I was younger. I thought I wanted to be a photojournalist and use the power of visual communication to make a difference.

**Learnt** photography at college - first at Middlesex Poly, while on a foundation course and then, when I was studying teaching at Homerton in Cambridge, I worked on the student newspaper "Varsity". Afterwards, I went to Nottingham Trent university and completed a BA Honours in photography. College gives you the time, but technique is something you have to learn on your own.

**Who** would I like to learn from? Imogen Cunningham. She was such an innovator and continued working all her life. I think we all need a mentor and I haven't found one yet.

**Favourite** photographer is Francesca Woodman. Favourite image is 'Self deceit 1978'. Woodman looks into a mirror, but her eyes are shut. She plays with constructed identity and self representation - a lot of the concepts behind photography.

**Best** critic is my husband, who is always very honest!, and my peer group from college. We meet once a month and critique our work. Best criticism is 'Be conscious of your materials. The subject matter and medium or materials you use have to be working towards the same goals'.

**Aspiration** to make images worth looking at and to be responsible for my imagery.

## Technique

*I am not a technical person. My work evolved the way it did because of that. I hate getting hung-up on technique. There are a lot of perfect, boring pictures. At the end of the day anyone can be technically proficient if they try hard enough. I do not have the patience and, anyway, I realised that it wasn't important to me.*

## Camera work

*The camera gives the world order, so contains part of it. I play a lot with the image, with multiple-exposures etc, so I am changing or manipulating what I see. I'm not really interested in documenting what is already there. I want to photograph more than we see, a different view, more aura and energy than reproduction.*

*Do I see the image before I photograph it? No, not really. I have well thought-out ideas, more like an essence of what I want. I do direct my models, but I also take a lot of film and edit later. I always hope something unexpected will happen.*

*I have no routine; it would perhaps be nice, but it hasn't happened so far. Equipment: Mamiya 645 and 80mm lens.*

*I don't always carry a camera. Only if I'm going somewhere new or different, somewhere I'll have time to take pictures. I don't carry one at other times because I'd take pictures I'd never print. Sometimes I don't take a camera on purpose, so that I can experience the place without looking through the view-finder.*

## Darkroom work

*I make proof sheets in one session, work prints in the next, 20x16" in the next (editing towards the final all the way) and then I have a session for test-strips, for mural prints followed by a long mural printing session.*

*I use filters, dodge and burn, and make the best print I can. It all depends on the image. What determines a well balanced print? Composition, tones - white to black and everything in between, shadow detail, and in focus if it's supposed to be; no dust. Other print qualities? Something else going on. I'm satisfied with a print when I can't bear the thought of being in the darkroom a minute longer.*

*How long might it take to make a print? Depends on the negative, the size of the print and my mood - anywhere from one hour to several days.*

*Do I laugh in the dark? Only when I have been in there far too long and the chemicals have got to me.*

## Post darkroom work

*Some work I tone and wash again.*

*I have been making 'Lightjet 5000' prints which are C-prints on archival Fuji paper. I have to get these done at a professional lab of course and so I lose control of the printing. However my monitor is calibrated to the lab's printer and so the prints have been consistent. I love the result.*

We all need a mentor and I haven't found one yet. I would like to learn from a professional female photographer or artist who has juggled family and work, who could give advice on organising time.

I went to a lecture by Robert Frank. He spoke about his life and work. He was so down to earth and open. I would love to learn from him. He made a lot of mistakes in his life and he isn't too proud to say so. His work inspires me.

Generally I value other peoples' opinions, although I think one must be selective. Art is a form of communication and so I am interested in how people respond.

I look at my proof sheets for a long time, usually cutting them up and arranging them in a sketch book, seeing how they work together. Then I make work prints and do the same. I may put them on the wall, and live with them for a while, to figure out what they are saying to me and what I want to say.

At first I resisted going digital, but eventually I found that what I was already doing in the darkroom (such as multiple exposures and other forms of manipulation) could be done with more

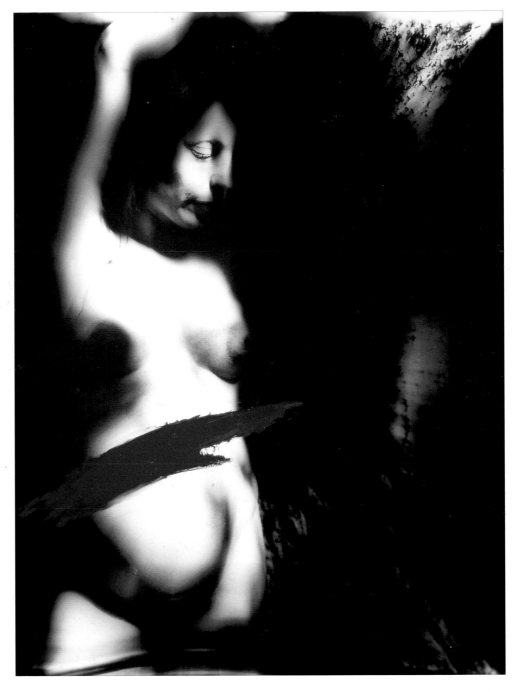

**Blur**

*A personal image. The picture contemplates the experience of woman as creator and the body as a vehicle.*

*The red slash symbolised her pain.*

*A silver gelatin, mural-size print. I moved the enlarger in and out to blur the picture.*

*It has shifted away from being a picture about pregnancy and now has its own quality.*

I have made some wonderful mistakes, that have changed the way I work.

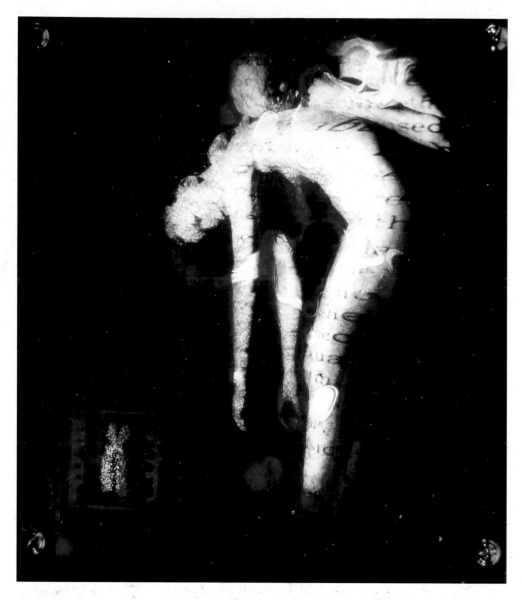

predictability, so I began to investigate. I thought I could make a living as a photographer, rather than as a painter, which was one of many misconceptions. I remember liking Andre Kertez from very early on, also Julia Margaret Cameron; this came from studying the Pre-Raphaelites. Also I liked Helen Chadwick.

I don't think I got any technical training at college. I learnt that when I started to teach from books.

My work is three-dimensional in real life. I guess my favourite image, the one that carries the most meaning, is 'Inseperable Environments'. It is of my husband and it was very spontaneous. It has a lot wrong with it, but I worked on it in a very impulsive way. It was done just before the next series, of which 'Infinity' and 'My Reality' are a part. Oh, I don't think I like all my work, what can I say!

Is 'Inseperable Environments' my most successful picture? No it's not, it's overworked and certain parts don't work. I guess I got a little carried away, which tends to happen.

I don't know how you rate success. My work has not been recognised yet! At least not in financial terms.

My most successful images (according to other people of course) are always the more minimal ones; less is more, and all that. It seems that in order for me to get a minimal image, I have to get a lot of stuff out of my system on previous pieces.

### My DNA Your DNA

*A personal image working on issues of identity and exploring ways in which we are viewed by medical recording methods, including DNA tests.*
*A silver gelatin print, dyed blue and mounted on a wooden panel which was painted with oils, over which was laid plexiglass, with a translucent layer of paint, for a three-dimensional effect.*

What determines whether I like an image is whether I can relate to it - in an emotional way. Of course subject and composition are important; everything has to work together and towards the same goal. There has to be a point to it.

There are too many pictures already that say nothing. I hate photographs that, for instance, exploit women. It's old, it's boring and we've moved on from there.

I use a lot of different media, but that is all connected to my photography. I think the teaching I do is and has to be creative.

When you walk into a room and have to inspire, encourage and relay information to a whole bunch of people, it takes inventive measures. Working with small or non-existent budgets also demands creative ability. Luckily, being an artist trains one to be industrious and to make the most of any given situation.

Am I a perfectionist? Yes, although I have my own standard of perfection and so it may not be obvious.

**Burning Point**

*A personal image. Inspiration came from Joseph Campbell's 'The Power of Myth' - following your bliss and finding the burning point inside The work draws on a connection between body and spirit.*
*Printed on Agfa FB paper as a black and white mural, I then toned it with sepia and copper.*
*It's very simple, but carries a lot of emotion.*

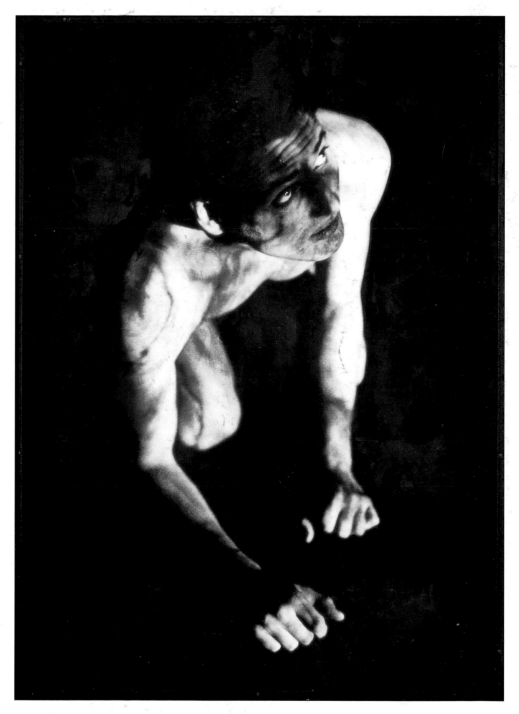

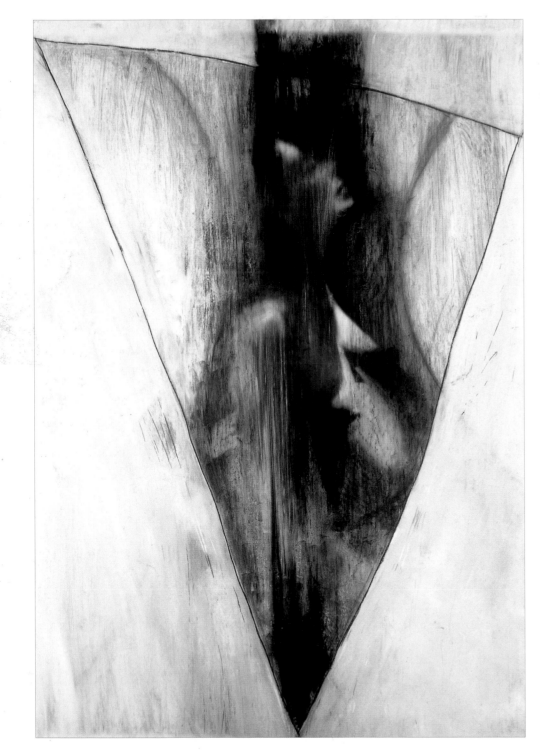

I have either been teaching or working in a lab since I left college, so I have used those facilities. When I have been without a darkroom I have used a computer. To print mural-sized photographs I use an enlarger on a track that can project the negative at right angles to the wall. The mural prints are usually 48" wide by about five feet. They have to be developed in troughs, and rolled continuously. I usually have some help to process them. It takes two pairs of hands not to kink the paper.

Ultimately my photographs are for me. I cannot rely on someone else appreciating them, although that is what I'd like. I don't think about this when I make them, they just exist.

Do I take holiday photographs? Yes, although the line is fine. When I got into photography seriously, I didn't take any fun pics and I regretted that after a while. I think it was because I was using a bulky camera and I just didn't want to lug it around.

Now I do take a lot of fun photographs. I may use them or parts of them for work. They differ in that they are a lot more documentary in style - straight, but mainly of people and often in colour. What appeals about the solitude of being

### Angel

*Another image dealing with pregnancy. I wanted to show power and physical stress. The image is also about metamorphosis and the experience of woman as creator.*
*A silver gelatin, mural print, painted on with acrylics, chalk and conte crayon.*
*It's the only time I've used acrylics and I think it worked. It was very spontaneous.*
*I like it.*

a stills photographer? I enjoy my own company as long as I get a break - I'm not a hermit. Also, I need to work through concepts and things take a lot of time - other people never understand what takes so long. There is never enough time.

For me a photograph can only be a reflection. It comes into being from reflected ideas and of course reflected light. I work through ideas by taking photographs. The spontaneity comes ˙later for me - in the studio or in the darkroom. It is what happens after the picture has been taken.

Photography: gift or graft? It is always hard work - having ideas, concepts, experimenting etc. Printing is a graft for me. I have to force myself to do it, but once I get going I can't stop. The final piece is always a gift, because it didn't exist before.

For the images in this book, I used black and white film, either Agfa or Tri-X. I set up the shoot, took the pictures, made work prints, enlarged them to mural size, later mounted the pieces, and worked on the surface with oils and acrylics. The paper I use is either Agfa FB or

### Inseperable Environments

*I took the picture in California among the eucalyptus trees. When I returned to England my ideas changed: I realised that the environment was very different - very industrial, and that my relationship with it was quite uncomfortable. I was now dealing with something harsher, so the colours became more toxic.*
*Photographed with a Mamiya 645.*
*A silver gelatin, mural print, toned and painted with coffee, oils, emulsion and collage.*

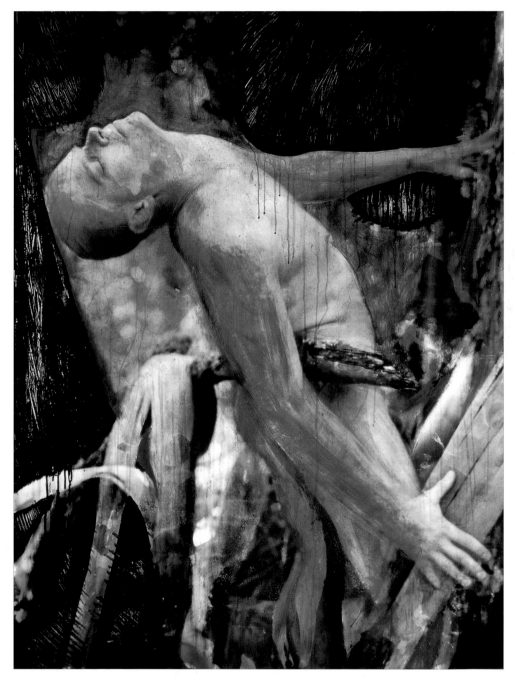

Looking is voyeurism, seeing is understanding.

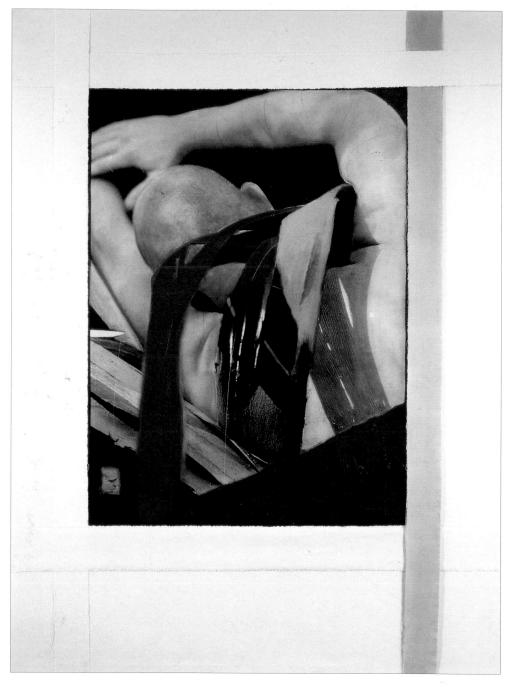

*After sight, my most important sense is touch.*

Luminos, depending on the piece. I move
the pieces into a painting studio from the
darkroom.

I mount the image and then paint it with
various media. Other work just gets the
film processing part done conventionally
and then the negatives are scanned into
a computer and manipulated using
Photoshop and Painter. I like the tactile
nature of working in a real studio, rather
than a virtual one, but I haven't been able
to afford one for a while and it has
forced me to find new and innovative
ways of working.

I think I am finally using the technology in
a different way and it allows me to do
things I simply couldn't do in the
darkroom.

The most important thing is that I have a
computer and scanner at home, as I do
not have a darkroom. I was already
working with collage, and Photoshop
allows me to do that without worrying
about scale. I can combine anything from
an insect to a photograph and I love
working in this very eclectic way.

The images chosen for this book were

### Infinity
*This image is six feet by seven - I wanted to give
photography the same scale as painting. I was
investigating man's relationship to the landscape,
how we become one with it, hide in it, get tangled
up by it and how insignificant we are physically. The
print was oil-painted and sewn onto canvas. I think
it has depth physically and conceptually.*

toned with perhaps three different photographic toners, then they were painted. I also use coffee and tea and various varnishes. They are all different. 'Infinity' and 'My Reality' were mounted on canvas whereas the others were mounted on masonite (wood).

My new work is scanned digitally at the negative stage using an Agfa Scann 11 SI and then worked on via Photoshop and Painter, with my Mac G3. Colour is added digitally, as is texture. I use a WACOM tablet instead of a mouse. I am beginning to play with different output paper, with different textures and also taking these images back into the studio to work on with real paint.

A photograph is a visual poem - a piece of time, a moment and a record.

Some of my work is very autobiographical, so it's more obvious. People see what goes on inside my head. I think I lay all the emotional cards on the table and open up in my work. They see the real me.

I get inspired by other artists, exhibitions, films, books, travelling and personal experiences. I think my work is based more in reality than imagination.

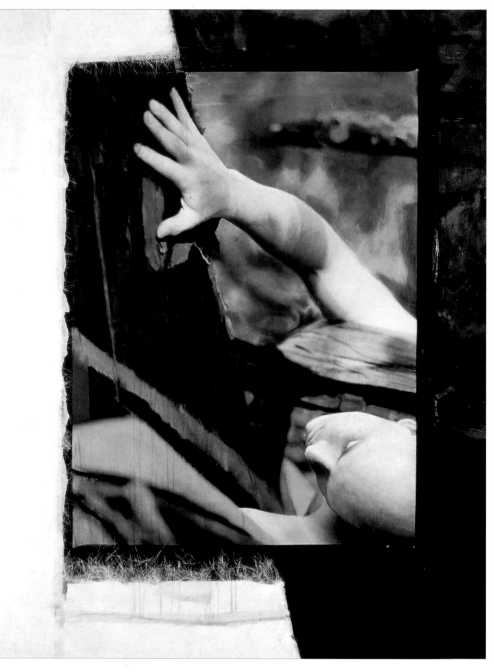

I find if I have a clear picture of the result in my head at the beginning, then it probably is a bad idea, after all it is better to keep an open mind and work uniquely with each project. One can rely too much on style.

**My reality**

*This picture was about struggle and grasping, wanting connection. The inspiration was man in nature.*
*Fibre-glass was collaged around the edges of the print and painted over. The frame is divided by texture and colour, to give tension to the scene.*

# Alun Callender

**Status** I am currently a freelance photographer, having worked both as a full-time and as a freelance assistant.

**Inspiration** Cameras and the act of recording have always excited me, and enabled me to go to interesting places, and meet fascinating people. Photography has me totally consumed.

**Learnt** at various full-time colleges which gave me a style and an approach. I haven't stopped learning from every experiment or from the hundreds of images I see every week that either influence or distracted me.

**Who** would I like to learn from? I would have liked to have assisted Irving Penn in 1950-51 when he was working on the small trades series in London, Paris and New York. When I first saw these images they were so new and so fresh that they completely transformed the way I saw photography, my approach to image making and the way I saw the world around me.

**Favourite** photographer is probably a great master like Richard Avedon, but my choice changes every day. My favourite photograph is a faded one of my mum and grandmother walking down Kensington High street in the fifties. They look happy and optimistic. It reflects the way I try to see life, my family and the friends I have around me.

**Best** critics are certain lecturers, colleagues, photographers and friends who have encouraged me, yet I know when an image doesn't work. Best criticism has probably been to work around an idea, to put the effort in and to explore every avenue of the concept during production, shooting and printing.

**Aspiration** to create a body of work which will still be enjoyed in the future.

### Techniques

I just take photographs, and what happens is what happens. I don't know if there is a rule book - it would be very restrictive; life would become one big amateur photographic competition. I believe there are certain technical disciplines that should be observed, but to break rules you have to know what they are first. Professionals should never make mistakes, they should only make experiments.

### Camera work

A photograph can only exist in a frame or in the crop that I impose on it, therefore the camera is the tool that I use to translate the 'real' world. Quite often I can visualise an image before I capture the scene, but the process invariably takes on a life of its own and becomes something that never existed in the first place. The mind and imagination work on so many levels, that for an idea to be translated to a flat piece of paper, some things have to be lost, while you can gain others in the photographic process.

Equipment: 35mm kit and a medium format system. They dominate my approach.

If one format isn't working, I just switch camera to change my view or attitude to the subject. I only carry a camera when I want to take photographs. It is important to enjoy life without the paranoia of missing a photograph.

### Darkroom work

The amount of time I spend in the darkroom is fairly limited so I stick to a standardised system: Tri-X through ID-11 for 11 minutes, Ilford Multigrade FB paper through Bromophen for 2 minutes, and finally selenium toner. After making contact sheets I have a good study of the images, then I invariably leave them alone for a month, before working out what I want to print. I use a test-strip to gauge the basic exposure and grade, and then follow my instincts of how I want the print to look. I usually spend an hour or two making a print, but if it is a portfolio image I invariably make a test print first, look at it once it is dry and then reprint it with extra dedication. Once I have squeezed everything I can from my negative, or if I get bored, I have got as far as I can, so I guess I am then happy. Equipment: I like sharp prints and to see the grain of the film, so I have a condenser enlarger for each format. At the moment I use Ilford Multigrade FB for straight black and white and Ilford Warmtone FB if I want to tone the image.

### Post darkroom work

I would like to use Photoshop more often for my image creation, but I think mainly for commercial work; going into the darkroom is now almost becoming a hobby. I am very excited about new technology, especially in the sense of having more control over the image.

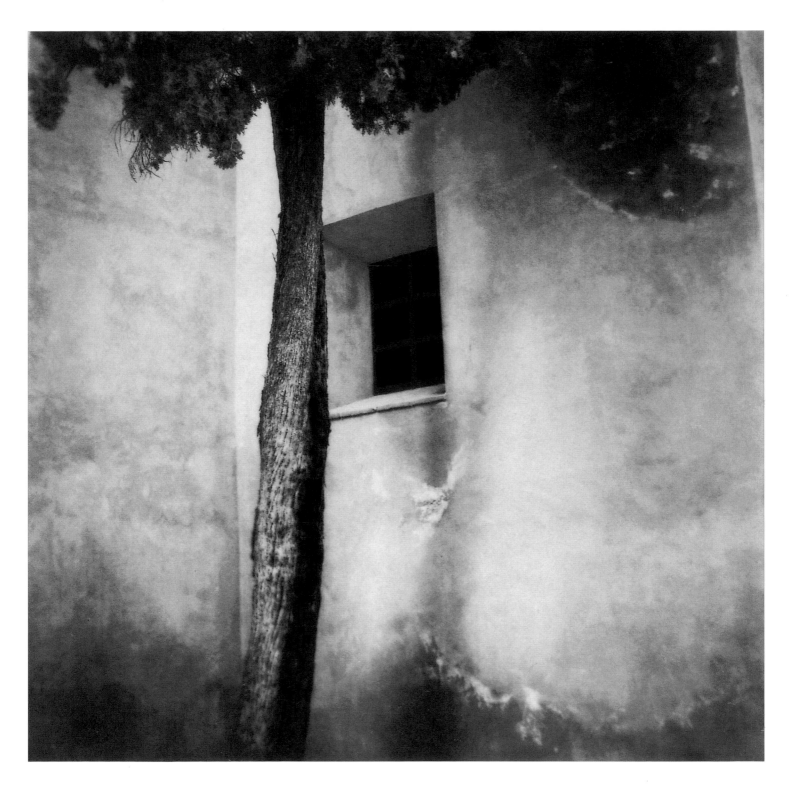

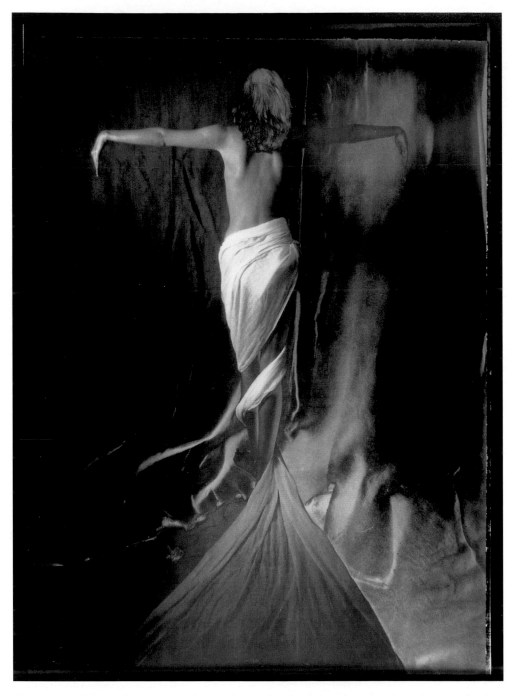

*I am always interested in what people have to say and if it is relevant I will take it on board, but I think it is more important to follow your own path.*

*My favourite images are the recent ones, but the new and the next photograph is always the most challenging.*

*Photography covers so many diverse aspects of technique, style, expression and concepts, so when the right balance happens an image works.*

*The image just has to work, having a true black, a clean highlight and greys in between, but again it's just a question of taste.*

previous page:
### Ronda 1997
*I was walking around this picturesque Spanish hill-town with a hangover, waiting for a bus to take me home, when I turned around to speak to a friend and I saw the tree and window. It just worked as a great composition. I hate clutter and mess. I just prefer to photograph very simply, using structure and form. I made the print on Ilford Multigrade matt FB which I then thiocarbamide-toned.*

### Nude series II
*The inspiration behind this image was the interest I have in the human form and, at that time, for that particular form. I shot the picture on Polaroid type 55 which I solarised during processing. The print was made on Oriental Seagull VC and thiocarbamide-toned. The image reminds me of an amazing period in my life.*

*The print is the photograph; it is where the image exists to the viewer. So the information the print holds is crucial to what you are trying to express.*

*Everyone looks at what is going on. But I feel that to see you often need to detach your brain from taking everything for granted, put a frame around what you see - to isolate it, then you can really work out what is happening in your vision.*

*I take photographs because some basic instinct makes me do it. It's a bit like collecting stamps but far more interesting, so I guess my photographs are for me and anyone else who wants to look at my album.*

*I usually give my snappy camera to someone else when we are all out, so I can appear in the photos and know that I exist.*

*I like to be in complete control of the images I make. I know how I want my images to be and I don't like to be compromised by other people's vision.*

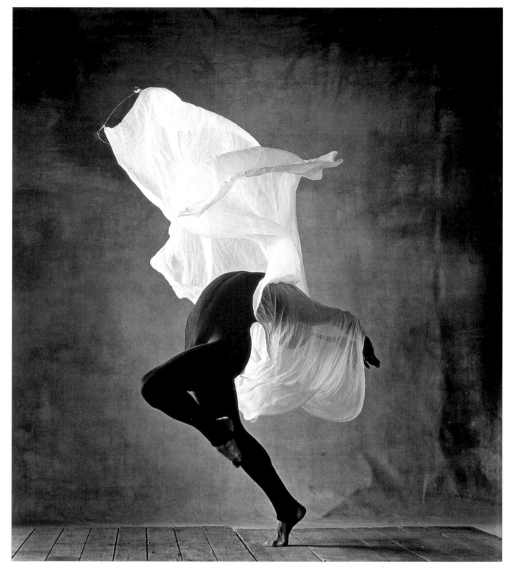

**Dance series IV**

*I have always been interested in the form that dancers create, and the energy they represent. Dance as an expression works on the elements of moving through time and space, whereas photography is a two dimensional art-form and I enjoy the challenge that this represents.*
*This is a straight black and white print on Ilford Multigrade, FB gloss, selenium-toned.*

*Some images just happen; the elements all fall together, whereas other images need a more cerebral challenge.*

*I follow my basic instincts about how I want the print to look.*

*I would like to have the money and motivation to be able to pursue my own photographs, working with and photographing interesting people, creating portfolios for a wide audience to be aware of my work and to enjoy my images.*

# Andrew Cockayne

**Status** Part-time, semi-professional.

**What** else do I do? Digital imaging for a major photo library and also for myself - which often involves little or no photography, and music

**Inspired** to become a photographer by the general feeling that I had creativity in me. I then took up photography, as opposed to, say, music or fine art, because I knew I could realistically make a living from it, as well as being creative.

**Learnt** photography at college, but I'm still learning as I practice photography or think about it, to some extent. Reading books, looking at other people's work, thinking of new ideas, and experimenting are all part of the learning process.

**Who** would I like to learn from? I try to avoid being influenced by other photographers because I'm conscious of imitating their style. It is definitely better to teach yourself as much as possible and to develop your own style and methods.

**Favourite** photographer is Anton Corbijn. Do I have a favourite photograph? There are too many to mention. It changes all the time; but one that springs immediately to mind is a picture by Nadav Kander of a woman in a swimming pool, wearing a bathing cap. It has a strange tonal quality, almost like a negative, which gives it an air of mystery. Also, anything by Anton Corbijn.

**Best** critic is me. I'm my own best critic because I'm the only person close enough to my work to constantly re-assess my strengths and weaknesses. Best criticism? When one of my course tutors at college told me I hadn't really lived up to my potential and I probably wouldn't amount to much! It just made me more determined than ever. Most people like at least some of my work. If they don't like any of it I just assume they've got no taste.

### Technique

*I love it. With it I can achieve my desired results, but I hate it when things don't work.. Rules can be broken; a good example is that photographs should generally be crisp and sharp, but I often take pictures that are deliberately de-focused.*

### Camera work

*Photography is just a different way of seeing. So you can show what you want to show with the camera, thereby emphasising certain things and excluding others. Nine times out of ten I plan my images, first making sketches and fairly extensive notes. Every now and then, though, I like to just experiment without any preconceptions - it's sometimes the only way to take my work in another direction. The only routine I have is to shoot something until I see the results, and then try and improve the shot until it is as close as I can get to perfect.*

*Equipment: Mamiya RB67, Manfrotto tripod, three tungsten lights and various stands and accessories.*

*Techniques: generally there is an element of double-exposure or montage. In this case I would make several prints and stick them on a background (usually a larger print). The prints are usually selectively toned first. When all this is complete, I re-photograph the finished work.*

*I very rarely carry a camera with me because I mostly work in the studio.*

### Darkroom work

*I throw away anything that I definitely won't print, make contact sheets of the rest and make crop marks with a chinagraph on the ones to print. Next I make test-strips to determine the exposure, then make another covering a larger area, until the right balance between contrast and detail is achieved. If I've got plenty of paper, I'll make several prints of slightly varied exposures. What makes a good print is rich blacks, slightly off-white highlights and a good range of tones in between. Sometimes loss of detail is okay, but not bleached out highlights. Tonal interchange is important - dark against light and vice versa. I prefer toned prints or prints on slightly warm-toned paper. I am satisfied with a print when it's as close to my original idea as possible. A print might take half to a full day to make. Do I laugh in the dark? Often, if someone else is sharing the darkroom.*

### Post darkroom

*I retouch as little as possible. I'm not very good at it. I've recently purchased a Mac so I'm using Photoshop a lot more. Retouching is a lot easier!, particularly with Polaroid negatives which are notorious for picking up dirt. Also, I can montage without having to physically stick prints on top of others, and I don't have to re-photograph the finished work. I output the work onto transparency via Lightjet, or with a photo-realistic printer.*

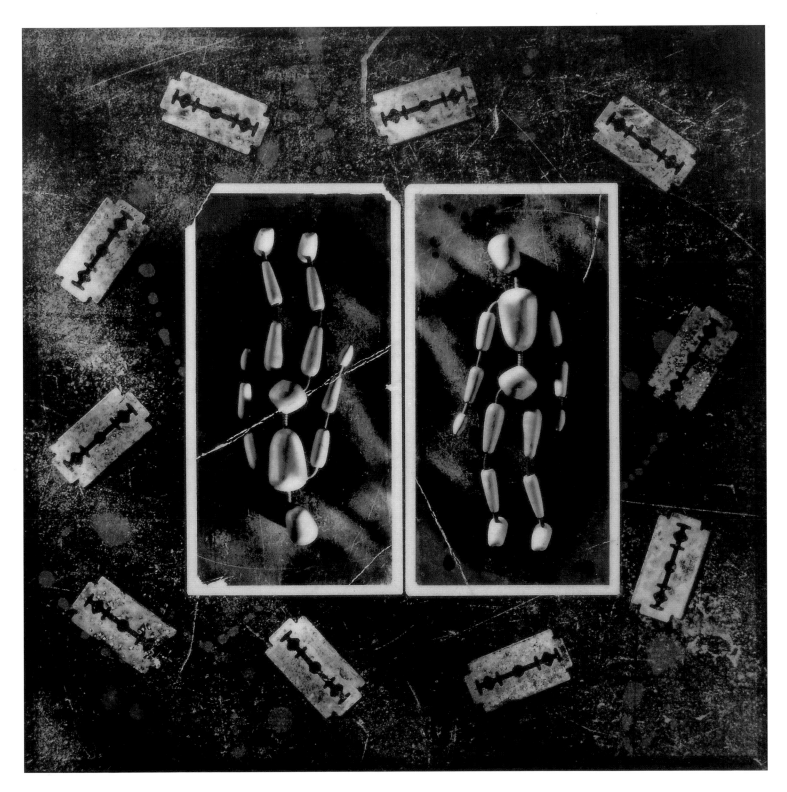

AI like the solitude of stills photography because it gives me total control and the time to do what I want to do. This isn't always possible, but generally I work best at my own pace with little interference.

Photography is about spontaneity and reflection. It is such a broad art-form, with many different styles and techniques; some pictures are almost accidental and capture a moment, whereas others are thought provoking and stay with me a lot longer. Basically it's whatever I want it to be!

Some people are naturally gifted (sickeningly!) and others develop over a period of time. With most people photography is a varied degree of gift and graft. You can't learn to be creative, but you can develop what potential you have.

Seeing is passive, like flying a plane on auto-pilot, and only requires a low level of thought and consciousness. Looking involves more thought and interactivity. For example, looking for something specific may involve the whole body - to walk around/through/into something.

Because my photography is mostly constructed in a studio, and is usually symbolic, in some way, imagination is everything.

What do people see of me in my work? My dark side and my sensitive side - a certain vulnerability sometimes.

What determines whether I like my work are the usual things: lighting, composition, good printing and so on, but also anything unusual and eye-catching, a different and novel way of seeing something, and a sense of mystery and ambiguity, either in terms of the subject matter or the picture's meaning.

'Vicious Circle' is my favourite photograph because all the work I put into it paid off. It took a long time and a lot of preparation, but it was exactly as I'd visualised it. Has it been my most successful image? That depends upon how you define success, but most of my favourite pictures are usually everyone else's favourites as well, so at least they're successful on that level.

If I hadn't taken the route I've taken, I'd photograph musicians, celebrities, artists, etc.. Who knows? I may still do this at some point.

previous page:
**Vicious Circle**
The idea for this picture just popped into my head one night. It summed up perfectly my state of mind at the time - fighting a seemingly losing battle against negative influences.
The print was selectively bleached, toned and artificially aged by creasing and staining with tea, also by weathering and rusting the razor blades.

opposite page:
**Scissors, Stone and Paper**
This image was inspired by the childrens' game in which scissors cut paper, and stone blunts scissors, etc. I honestly can't think of a word or sentence that sums up the picture, so I'll leave the viewer to decide.
The black and white print was ripped and montaged, bleached and toned.
I still like the idea for the photograph, but I think I could it do a lot better now.

# Andrew Davis

**Status** Amateur/part-time professional.

**What** else do I do? I'm a stone mason. Being a stoneworker is mentally relaxing.

**What** inspired me to become a photographer? Photographing bands at gigs; also the work of Anton Corbijn and Man Ray.

**Learnt** by teaching myself, with a camera I got for Christmas.

**Who** would I like to learn from? My photography is personal, but Eddie Ephraums for printing (master chef of monochrome!).

**Favourite** photographers are Man Ray, Albert Watson, and many more. Favourite photograph? - too many to mention.

**Best** critics are my flatmates, who always see the prints in the bath. Best criticism came from the photographer China Hamilton, who told me that I had a rare gift. Other peoples' opinions are important, although I do get upset if they don't like something that I do.

**Aspiration** to produce a book one day.

### Technique

I like my technique, it still has magic.

I can never predict exactly how the tones will come up although I do follow the rough rules of the chemistry.

I like meddling around to create different effects.

I never seem to learn from mistakes.

### Camera work

The camera opens up my view of the world.

Do I pre-visualise the image? Yes, a little, but mainly when I look through the viewfinder and print in the darkroom.

I do have a kind of routine. I develop my films, then the contacts, and then I go through them and decide what to print.

Equipment: Bronica ETRS, and 40, 75, 105 and 150 lenses, plus a red filter.

Do I always carry a camera? No.

### Darkroom work

Do I work to a system? I print out the pictures from a photographic session, then I tune them.

How do I decide which negatives to print? Looking closely at the contacts over a beer. I just test prints to determine print exposure times.

What determines a well balanced print? I don't really know, I just sense when I get it right.

Atmosphere is important, the 'being there' approach.

I am satisfied with a print when it is dry and I look at it in the daylight. It takes me about 5 minutes to make a print and then the hours of toning.

I develop HP5+ and FP4+ in Ilford's Ilfotech.

Equipment: Durst M670. I use Kentmere Kentona paper and I prefer a developer like Agfa Neutol WA for its olive colour, which I do like on its own, but I often tone the print as well.

I also do a lot of lith printing with Kentona and Champion Novalith developer.

Also, I used to do a lot of split-toning, but now I mainly do a lot of split-grade burning in.

Do I laugh in the dark? Yes, when I turn on the light.

### Post darkroom

I like to use sepia or blue toners.

I'm usually lucky and don't have to do too much spotting. As far as digital technology goes, I am working on a website for my photographs.

Yes, I am a perfectionist, but impatient.

My favourite images are 'Paris Metro I and II. Is it successful? I don't know what is meant by successful to me or to other people, but, yes, when I get it 'right' other people agree.

I like a picture if it can convey a mood. I'm not really bothered about sharpness etc.

Seeing and looking are both the same to me. I'm never off duty with my camera.

My photographs are for me firstly, then everybody else.

### Paris Metro I

*The inspiration for this picture was simply being there, wanting to capture the moment. I suppose 'dreaming' best describes the image. The print was made on Agfa Record Rapid, bleached and then sepia-toned. I still think it is powerful.*

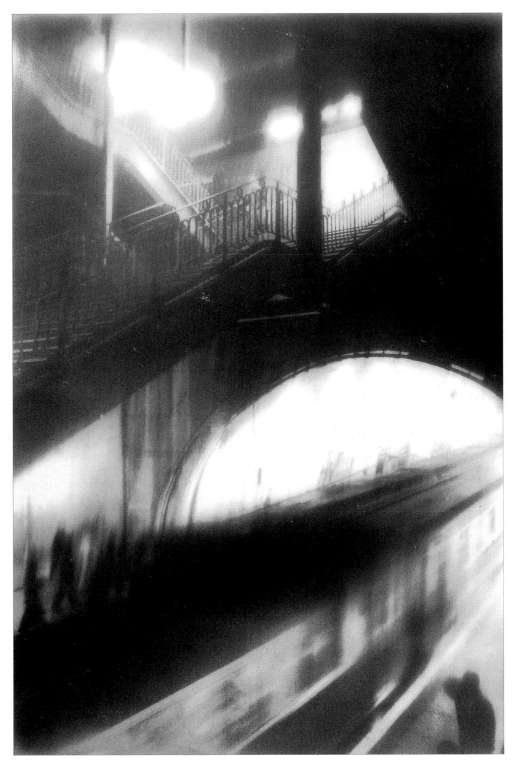

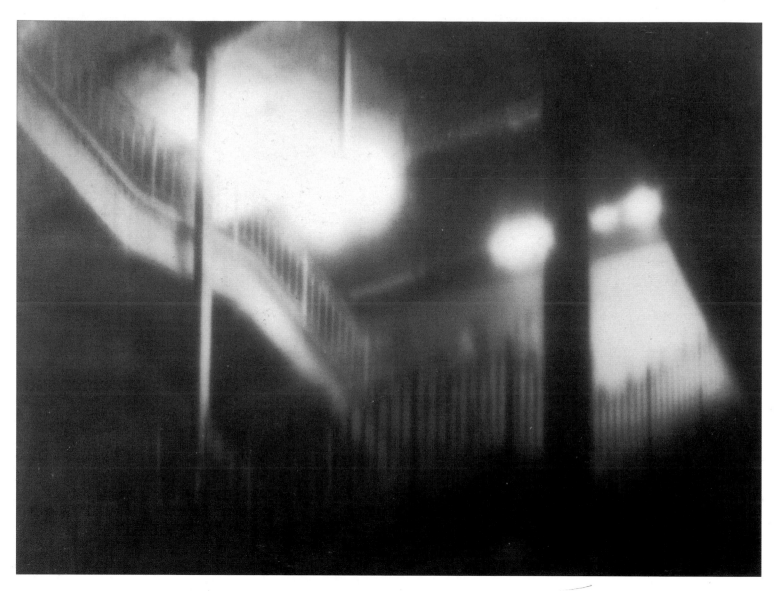

### Paris Metro II

*I wanted to convey the dark, moody light of the Paris Metro - to capture its atmosphere.*
*The print was made on Agfa Record Rapid, bleached and then sepia-toned.*
*The picture is over five years old, but it still works for me. Personally I don't fault it.*

Work and holiday photographs are the same. I shoot black and white on a mediterranean beach.

*I like the way nobody can see exactly what I take, nobody can put their eye in the same place.*

Photography is both a gift and a graft. First you must have the eye, then follows the graft in the darkroom, but this is a labour of love.

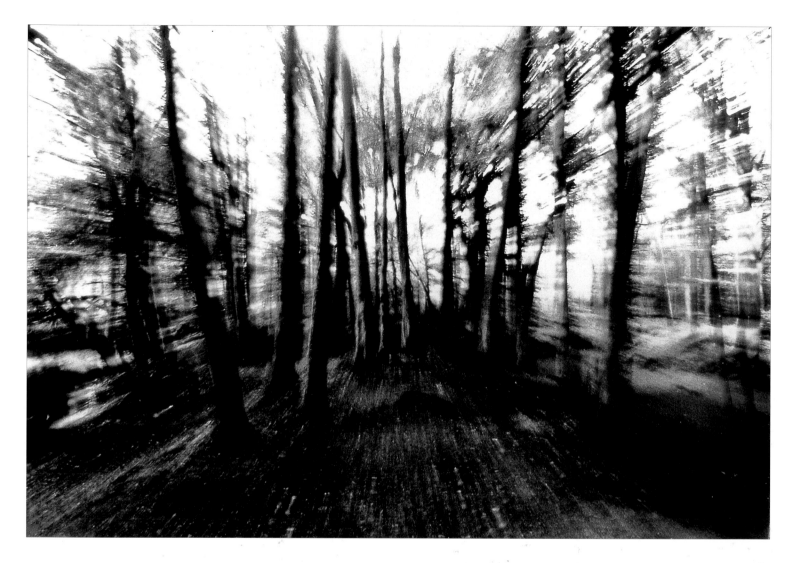

**The Woods**

*This was a personal image, but it has just been used for a book cover. It was the eerie quality of the woods that inspired me to make the photograph - with the wind it was quite scary.*
*I used Ilford Galerie and blue-toned the image.*
*I still find it as strong a photograph as when I first made it.*

*What can people see of me in my work? My imagination, I think.*

*Photo heaven is a moody sky and a red filter, or how much materials I could get in to a trolley at Silverprint in an hour.*

*I have a very active imagination and I try to reflect it in my work.*

*Long live monochrome!*

# McVirn Etienne

**Status** Full-time professional.

**What** else do I do? Music, woodwork, song, dance, playing the guitar and martial arts.

**Inspired** to become a photographer during a summer holiday in 1986, when I borrowed a friend's camera.

**Learnt** the self-taught way, with books and magazines.

**Who** would I like to learn from? Nick Knight, because he is very versatile and manages to capture personality and spirit in his subjects.

**Favourite** photographer is Nick Knight. Favourite photograph is the 'The Corset' by Horst. It is an image that will always stand the test of time - erotic without showing hardly any flesh; strong yet subtle.

**Best** critic is my ten year old son. Best criticism is "Less is more". I value other peoples' opinion, especially if it's good.

**Aspiration** is to travel the world and photograph all of its wonders, and to enjoy myself doing it.

## Technique

*I have applied different techniques, but hate it when clients don't appreciate different approaches. What rules do I follow? Always send an invoice with the job! Mistakes have taught me never to do them again.*

## Camera work

*The camera opens up my view of the world. With it I see beauty in a lot of things I wouldn't normally see. People look at me like I'm weird when I marvel about the texture of a peeling wall!*

*I see an image in my mind and start to create it, but more often than not something will come to mind in the middle of the shoot.*

*A routine? No, suck it and see! That's my motto.*

*Equipment: medium format and large format cameras, some old flash heads - Bowens, and the best accessory any photographer can have, a CAR.*

*Do I always carry a camera? No, unfortunately.*

## Darkroom work

*My darkroom system: dry area to the left, wet to the right. I always check the lids are on the developing tanks and paper boxes before the lights are switched on. Also, I always try to remember to set a 'get out of the darkroom time' if I can, but that never works!*

*If I like the image enough when I first see it, I'll print it even if it isn't sharp; it's that first reaction that I will decide on.*

*My 'guessing eye!' is my print exposure method.*

*I like good density in the dark areas, plenty of tone and scale, clean highlights and good contrast. Other print qualities? A sense of feeling, especially in my black and white prints, also texture and clarity.*

*I'm satisfied with a print when I don't need to compare it with a previous one I've made.*

*A print might take twenty minutes to make, sometimes a day.*

*Equipment: 5x4" black and white/colour enlarger, sink and trays, and a finishing area. I print black and white and colour.*

*Do I laugh in the dark? Only when I'm printing self-portraits.*

## Post darkroom work

*I don't do a lot.*

*My prints usually go out as they are, without much need for any retouching. Computer technology has meant being able to send my work anywhere in the world without giving up any originals.*

*I output images onto CD or ZIP drive.*

My own favourite image is 'Despair'. I think it shows how the subject was feeling without even showing his face. He just wanted to hold and comfort himself. After I shot it, I knew I had captured him in the right way and I decided to include it in an exhibition I was planning. Despite the fact that I didn't market it properly somebody did pay £250 for a print after seeing it in a photo lab.

I am very critical of my own work and I have been told off for throwing away decent prints! I like to see spirit and feeling in images, but I also like to see good technique practiced. I hate putting boring images in my portfolio, just because a client has decided to publish them.

**Silver Ball Player**

*The subject was an extra on a video shoot and I asked him to pose for me - a real sport's showman. I am glad that I acted quickly in shooting him. I can't imagine how he could play ball with those rings, but when he did he must have commanded attention.*

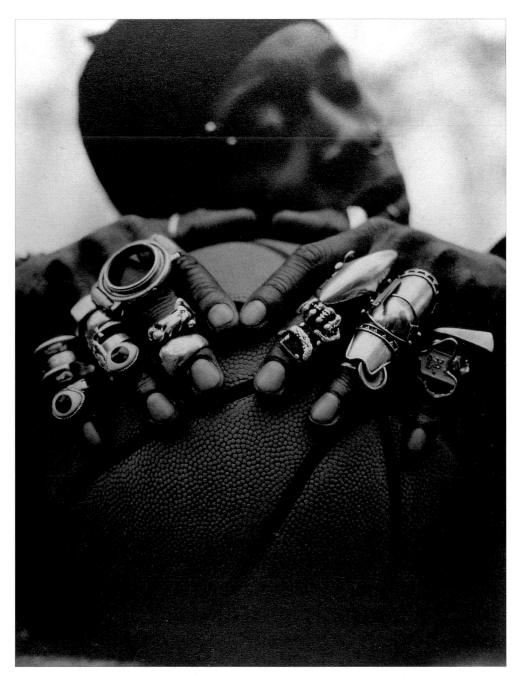

Touch is my other most important sense. You can feel shape as well as see it. When you see something, it imprints on your retina, but when you are looking - searching for something in an image especially, it imprints on your memory.

Am I a perfectionist? A little bit.

I make my photographs for myself first, then my clients.

**Hatching Egg**
This and 'Holding Wheat' were speculative images. I was pitching for a job to shoot the hands of the singer Desiree. Both images were shot on black and white film and then printed on colour paper.

*What is it about being a stills photographer that appeals to me? You don't need to rely too much on anyone and you are the most important person in the studio.*

*Is photography about spontaneity or reflection? Put it this way, I have a very bad memory, but I can remember everything about a photograph and what I did the day I took it.*

*Photography is a gift, so long as you are allowed to be as creative as you want.*

**Holding Wheat**

*I thought this image captured what I was trying to say, which was what sustains us.*

A photograph is an encaptured moment in time, never to be repeated.

What people see of me in my work is that I try to bring personality out in my photographs; I always want to seal what's inside people.

Photo heaven would be taking time out, shooting in exotic locations around the world and to sell my images for a lot of money, so that I can do it all again.

### Shake it Loose

*This is a picture of my brother. He had his dreadlocks tied back and I wanted his hair down. I told him to shake it loose. As he did, so I liked the look of it, and I began shooting. He got a bit annoyed with me that I didn't shoot more of his face, but to be honest this looked much better! This series of images got sold for a book cover.*

A photographic wish would be to capture an image that would be recognised worldwide and that captured a period of my lifetime, that my image and myself will always be connected with.

I would say imagination is everything, well 80% anyway.

The hardest thing is trying to keep the same feeling in my professional life that I had when I was an amateur - the enthusiasm and feeling of anticipation that is not there all the time when you turn professional. I still love my work, but when was the last time anyone of us got up at dawn in the middle of winter just to photograph a sunrise for fun?

### Despair

*The subject was going through some troubled times and needed someone to talk to. He came to me and we ended up making this image, that reflects his inner pain.*
*It was shot on 5x4" film and printed on Ilford Multigrade. The picture still makes me a little sad.*

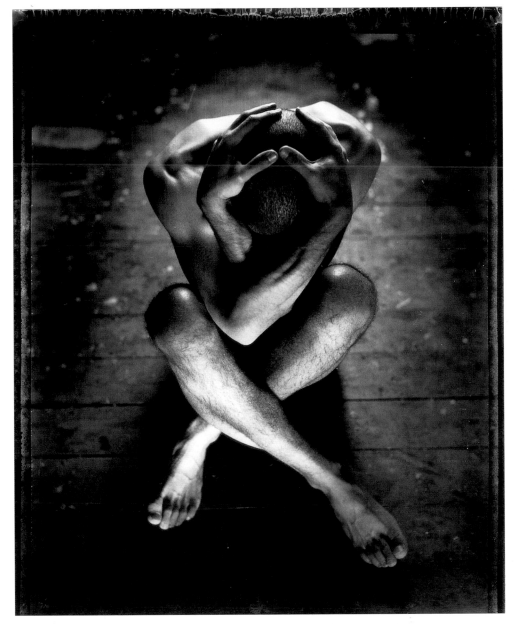

# Roderick Field

**Status** Full-time professional.

**What** else do I do? Write poetry, learn from my three and a half year old daughter and offer impromptu counselling.

**Inspired** to become a photographer firstly by my father - there are thousands of slides from the early sixties (Kodachromes), and some are outstanding. Later it was the joy of printing properly, thanks to the help of various professional printers. So, is photography a passion? Absolutely.

**Learnt** the hard way.

**Who** would I like to learn from? George Rodger - humanitarian, creative, intelligent and still interested after fifty years.

**Favourite** photographer? August Sander. Favourite photograph? Any of the trades people - Sander gave dignity to the common man and had the confidence for epic undertaking.

**Best** critic is John Hamilton - Penguin books. Best criticism: 'Take your work seriously and get organised - after all it is a business too'.

Do I value what people say about my work or disregard it? Both - depending on the critic.

**Aspiration** is to speak clearly and be heard. I see photography as the only true international language. As I have the ability to use language well, I aspire to pinpointing what it is I have to say.

## Technique

*It has to be thoroughly learnt so you don't have to stop and analyse. The best work I do comes from streams of consciousness and focused concentration.*

*What rules do I follow? Printing full-frame - ruthless editing.*

*What have mistakes taught me? To be alert.*

## Camera work

*The camera frames tiny bits of the world and opens them up for everyone to see.*

*Do I see the image in my mind before I make a photograph? With constructed images (ie book jackets) there is no other way. Firstly I find a place, second I find the people and third the props. The moment of looking through the viewfinder and seeing your vision is one of the most powerful experiences I know with reportage work (and a recent shift into colour transparency). Waiting and anticipating give the greatest rewards.*

*Do I work to any other routine? Maximum possible aperture (shallow depth of field) and elements of movement - like frozen movie frames*

*Equipment: Nikon 35mm kit and Bronica 6x6 outfit.*

*Invariably I shoot black and white, people and their environment - hand-processed ISO 400 and hand printed.*

*Do I always carry a camera? No.*

## Darkroom work

*Being systematic is necessary in the dark. However, I can't deal with test-strips - I always follow my instincts and judge print grade and exposure times on full sheets of paper - then adjust accordingly. Straight printing is my favourite.*

*Negatives choose themselves - it is often obvious which is the winner and which are the also ran's. What print exposure methods do I use? As I said, guesswork.*

*I like a straight print with true blacks and just enough highlight detail to take the 'Persil white' out. Also, corner to corner pin-sharp grain is very important to make an image sing. Every print has a point at which it achieves optimum visual impact. I am satisfied with a print when it achieves the above.*

*I usually get a print right on my second or third attempt.*

*Equipment: two enlargers: 35mm and 6x6, a big sink, big trays and a big stereo.*

*Do I laugh in the dark? Yes, when things go wrong and there is no alternative. I also sing loudly when printing on a good day.*

## Post darkroom work

*Spotting, flattening and invoicing.*

*Computers give the opportunity to my wife to do my invoices. I am computerphobic.*

*Am I a perfectionist? Unfortunately - yes.*

*My favourite photograph of my own is the single portrait of Mark. This is a very early wide-angle photograph (1985). It has a magical, quiet intensity - also it was my first BJP cover.*

*What determines whether I like a photograph? Whether or not I am moved by it.*

*Apart from sight, my other most important sense is hearing. When printing, the music has to be loud enough to stop my mind wandering.*

*Seeing is taking the world for granted, looking is finding the hidden treasure.*

*My photographs are for me first, the world second.*

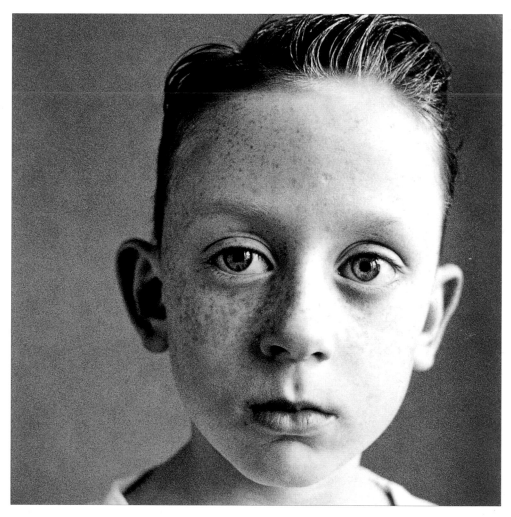

**Mark Allen**

*A personal image; I have always been fascinated by the subject of childhood. I feel this photograph gives it a timeless quality.*
*The image was put together very simply using natural light, a 28mm lens and printed straight. I feel it has stood the test of time.*

*Do I take holiday or fun photographs? Yes - an on-going project is photography taken from the hip without looking.*

*I have always been a loner, so the solitude of stills photography appeals to me.*

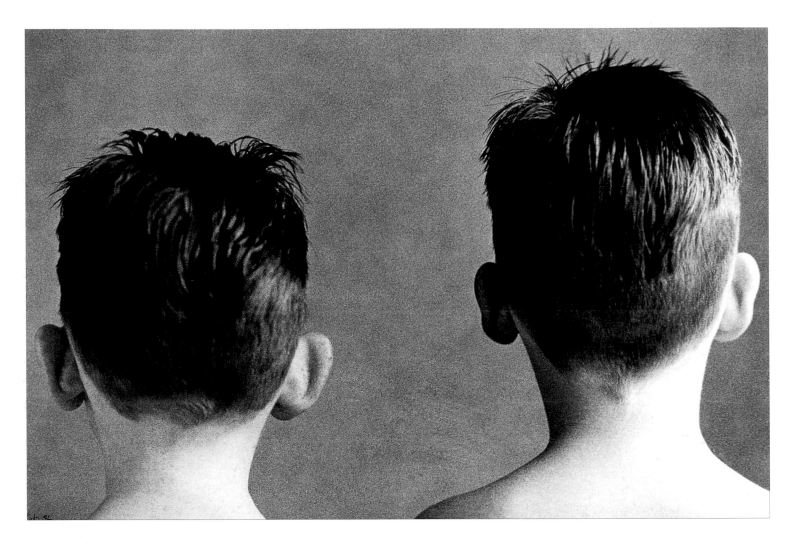

In photography there is room for both spontaneity and reflection. I like to reflect on how to make photographs spontaneous.

**Glen and Mark Allen**
*They agreed to sit for this portrait on condition that I cut their hair first
(I knew that training would come in handy.)*

The gift may be there, but the key to exploiting it requires luck and lots of application. Without graft, the opportunity to grow and practice is denied.

A photograph is a short story. A good photograph is a poem.

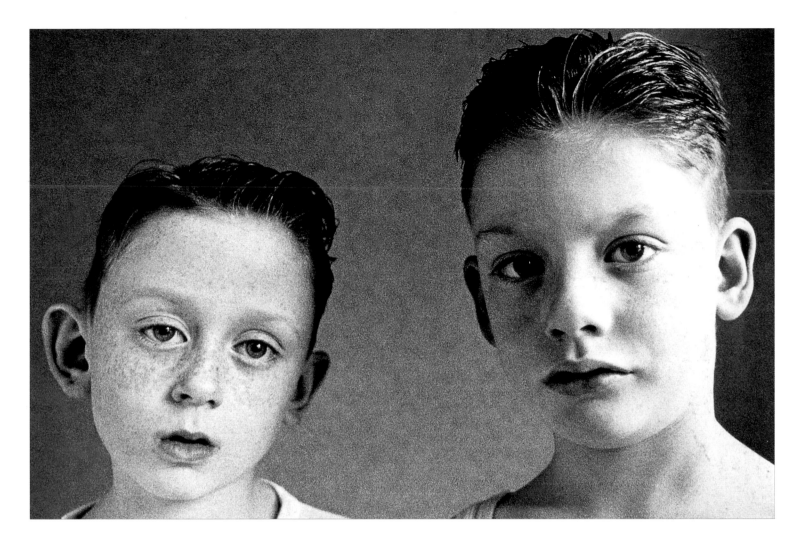

**Glen and Mark Allen II**

*This is now a historical document - twelve years later the boys are men - tattoos, piercings and usually down the pub.*

I hope what people can see of me in my work is an obsession with human nature - gestures, expressions, movement and occasionally spirit.

Photo heaven would be to keep learning, stay motivated, see things I've never seen and communicate clearly. A photographic wish would be for someone to contact and file all my negatives, including the six years of work my ex-wife cut up and flushed down the loo in 1987!

Imagination keeps my photography alive.

# David Gibson

**Status** Professional photographer - in theory, but in practice I do not work every day.

**What** else do I do? No other work at present.

**Inspired** to become a photographer very gradually, from just an interest, to the point of taking a two year course.

**Learnt** photography? Not in the strictest sense. Towards the end of my course I wrote a dissertation on 'Humour in Photography' and my awareness of documentary/humanistic photographers was deepened considerably. This was probably the true starting point and what gave me the inspiration to take photographs in a similar style and spirit.

**Who** would I like to learn from? Any of the great photographers whom I admired over the past ten years, particularly Henri Cartier-Bresson, simply because he is probably the best.

**Favourite** photographer? There are several photographers who I admire, though the list is not rigid. Certainly Henri Cartier-Bresson, but also others like Marc Riboud, Elliot Erwitt and Mario Giacomelli. It's impossible to have an absolutely favourite photograph - some perhaps become too familiar. The more obscure images, by lesser known photographers, can be equally rewarding. I like Raymond Moore's work, for example, because it is very understated and quiet.

**Best** critic is hopefully myself, or at least I should be. Best criticism is rejection - in competitions usually. Sometimes the reasons are not clear, but it has caused me to think again.

**Aspiration** Apart from earning sufficient money from it - to eventually assemble a body of work which is lasting and of value. A retrospective book would be nice.

### Technique

*I am not a technical person. I found photographic theory at college very difficult. The only technique I have is looking at the work of other photographers.*

### Camera work

*I suppose I frame the world around me. I isolate scenes that interest me. I have only ever cropped one photograph and I have only once partially set up a photograph. I am not religious about this - I just think that it shows and probably devalues the work. My contact sheets are full of bad and very ordinary photographs. These are in a sense my mistakes, my practice, my warming up for something better. Do I see the image in my mind before I take the photograph? Almost exclusively I come upon a scene, looking for the moment and having a sense of what might possibly unfold.*

*Do I work to a routine? Only in the sense of when the mood takes me, when I feel that I want to take photographs, or if there is some event taking place that interests me.*

*Equipment: two Nikon FM2 bodies with a few lenses. I use the 50mm the most. I experiment sometimes with out of focus shots, particularly with longer lenses.*

*I don't always carry a camera. I tend to be much more selective now, more deliberate about when I take my camera with me.*

### Darkroom work

*Do I have a darkroom system? Only that I select certain negatives to print. How do I decide which negative to print? Endless pouring over contact sheets. It should be instantly obvious if a negative is worth printing.*

*My print exposure method is generally to stop down to f8. Exposures tend to vary. A print is well balanced when it looks right. What other qualities do I look for? There is a certain arrival point when the print just looks comfortably right. For an important print, it might take me up to an hour to make, sometimes longer.*

*Equipment: I hire a darkroom with a Durst colour enlarger. I always use a ground-out negative carrier. I like to print full-frame, with a rough key line.*

*Laugh in the dark? This is the best question. I don't laugh much in the darkroom. Because I hire a darkroom there is always a certain pressure to finish within a given time. Increasingly, for important prints, I use professional labs. I can then relax and maybe they can laugh at one of my photographs.*

### Post darkroom work

*Apart from spotting, I leave prints alone. If they are good enough, I have them mounted for my portfolio.*

*I am a little wary of computer technology and have yet to really embrace it. Am I a perfectionist? In photography, yes.*

*Whether I listen to the opinion of others depends upon who the opinion is from.*

*I tend to be quite dismissive of praise but I do listen to the people whose opinion I respect. The best praise is when somebody buys one of my photographs from a gallery wall.*

*My own favourite photograph is 'Ascot - Monsieur Rene'. It is the most recognisable, as being my style. It is very precise and has a certain mood. It also has a timeless quality about it. Amongst all my photographs, I do not have an absolute favourite. There are probably a dozen or so images that I am proud of, and some of these I have sold at exhibitions. In terms of usage, other images have sometimes been more successful, probably because they are more anonymous and adaptable. The three images here would fit into that category.*

*What determines whether I like a picture? It is instant - a photograph works or it does not. You cannot force it. When it works you are compelled to look at it. I like photographs that surprise me and make me smile.*

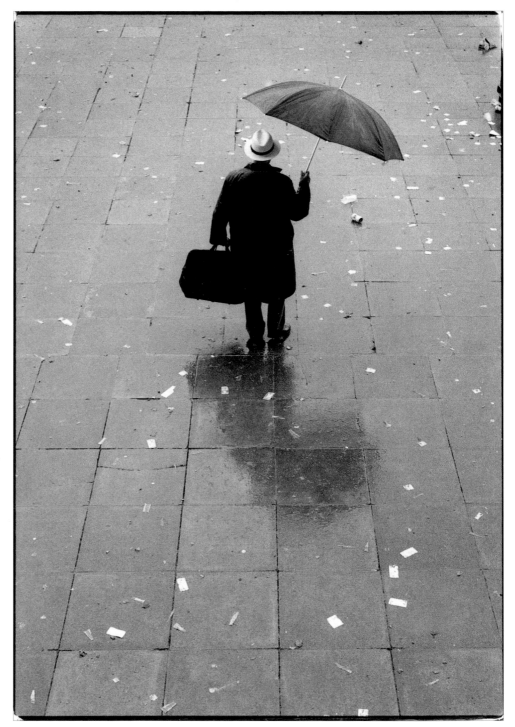

**Ascot - Monsieur Rene**

*Some photographs have a life of their own. This one was used for the cover of Peter Ustinov's book, 'Monsieur Rene'. The photograph and the man in it now have an identity.*

*The picture wasn't commissioned; it was a personal shot. I like the subject - an interesting man with a certain style.*

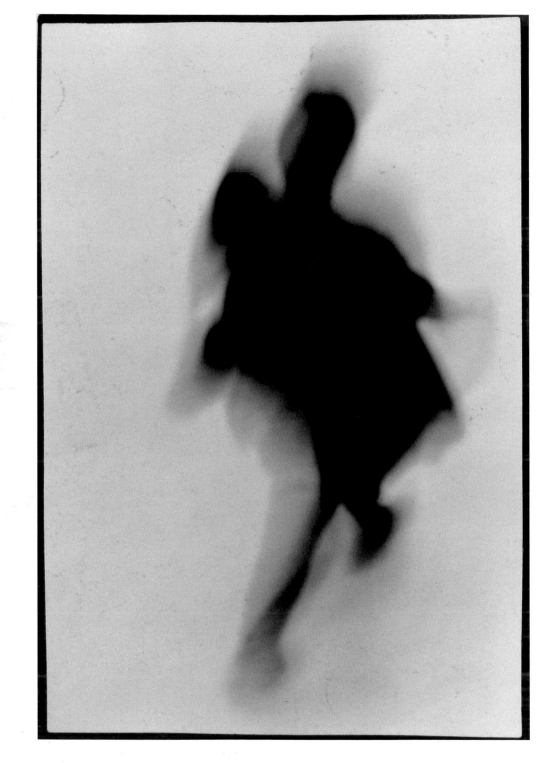

It is easy to look. It is what we actually see when we look that counts.

My photographs are for myself mostly, but if they are good they hopefully resonate with other people - therefore, in a sense, they are for sharing.

By necessity, the kind of photography that has interested me so far has mainly been solitary. Street photography tends to be a solitary occupation.

Mostly photography is about spontaneity. Increasingly for me I need to be fired up and hungry for the luck that sometimes happens. That is the theory, anyway.

About photography: I think that if you are good at something you tend to pursue it - the route of least resistance. However, a spark is always needed, some sort of inspiration or need.

My post darkroom technique is to put my prints in a box and have a cup of tea.

What is a photograph for? There are many answers to this: confirmation that we are all really the same and that sometimes we look rather odd.

**Blurred Man**

A personal image, experimenting with out of focus and slow shutter speed techniques - I was trying to capture movement.
A straightforward print, but printed quite hard.
An ordinary photograph, but most probably very useable all the same.

What do people see of me in my work? Some people are rather indifferent, other people might see something very carefully considered and quirky. There is probably some truth in that you can tell much about a photographer by the kind of photographs they take.

Photo heaven would be somewhere new, something stimulating to photograph - my potentially lucky moments in one place.

A photographic wish would be that I could earn sufficient money from it, stay curious, and continue to get satisfaction from it.

What role does imagination play in my photography? Imagination is reaction.

'Photography is a business that thrives on insignificant praise.' This is a quote from an article I read a few years ago. I think that this is a very telling comment on how photography functions.

The most satisfying moment is looking at some good prints in the evening after the day's work in the darkroom.

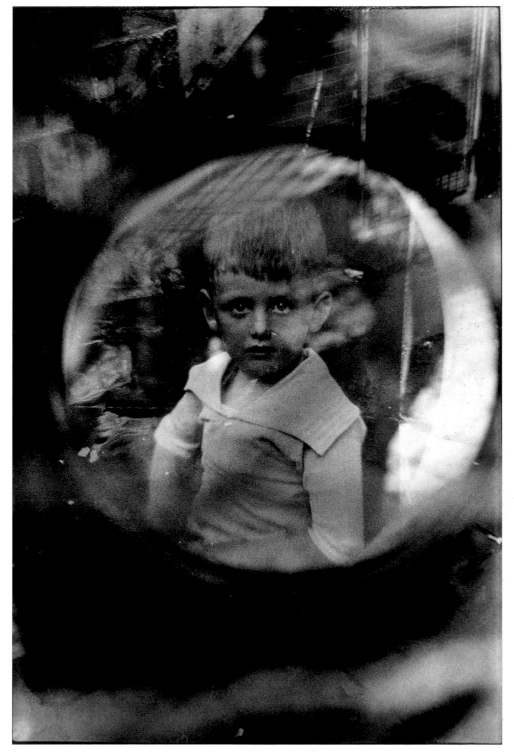

**Old Photograph**

The image was made in the window of an antique camera shop. It is unusual and I knew instinctively that it would make a very usable picture.
In a sense it is not my photograph. I just saw the combined effect of the photograph seen through an old lens. It is mysterious and I can't help wondering who the boy was.

# Jon Hatfull

**Status** Part-time professional.

**What** else do I do? I make 'art pieces' that are combinations of photography and ceramics, also drawing upon woodworking and light building skills.

**Inspired** to become a photographer by visual curiosity. Is photography an essential part of my life? A part, yes.

**Learnt** photography how? Self-taught/books.

**Who** would I like to learn from? Arnold Newman for his perception, Gary Winnogrand for his vision, Deborah Turbeville for aesthetic 'feel', Josef Sudek for 'magic' and Aaron Siskind for pure composition.

**Favourite** photographers are the same as above. Do I have a favourite photograph? None and many.

**Best** critic? No-one fits the bill (yet). Best criticism was when I was accused of being 'process-led'. It made me aware of my lack of sympathy with current 'Arts Council' attitudes. Do I value the opinion of others? What they think is usually interesting.

**Aspiration** - essential moments.

### Technique
*Techniques define the medium.*

*To push out a medium's boundaries, one must first know where they are, but one must always remember to push. What rules do I follow? The way I see things. Mistakes have taught me resolve.*

### Camera work
*The camera helps me to contemplate what I already know.*

*Do I see the image in my mind before I photograph it? I have learnt to see how the camera sees and respond to what will work within the limitations of the medium.*

*What routine, if any, do I work to? Start late, finish late.*

*My own work is predominantly 35mm (Nikon). I can't remember when I used a shutter speed faster that 1/15 second - usually with slow film (100 ISO), and slow sync or fill-in flash.*

*Do I always carry a camera? I used to try to, now I don't bother.*

### Darkroom work
*Do I work to a system? I have habits, but no conscious system.*

*What process do I go through in deciding which negatives to print? From a contact sheet/proof I choose either the closest to my expectations from the shoot or, more often, I hope for some surprises.*

*I don't use any special print exposure methods.*

*Often I will bleach with ferricyanide and sepia split/partially tone black and white prints. Also, I sometimes print black and white images on colour paper, through the RA4 process.*

*What determines a well balanced print?. A balance of tones, not necessarily a full range of them.*

*What other qualities do I look for in a print? Those appropriate to the desired aesthetic.*

*I'm satisfied with a print when I feel it works.*

*A print can take anything from half an hour to several days to make!*

*Equipment: Durst M707, De Vere 203 and 504..*

*Do I ever laugh in the dark? Nice question!*

### Post darkroom work
*Spotting' in Photoshop is wonderful. I output to 5x4" negatives and reprint these conventionally in the case of bad negatives or tiny parts of negatives.*

*I use a borrowed Apple Mac for this work.*

*Am I a perfectionist? Not at all, I'm a deprecisionist.*

Hatfull - 2

67

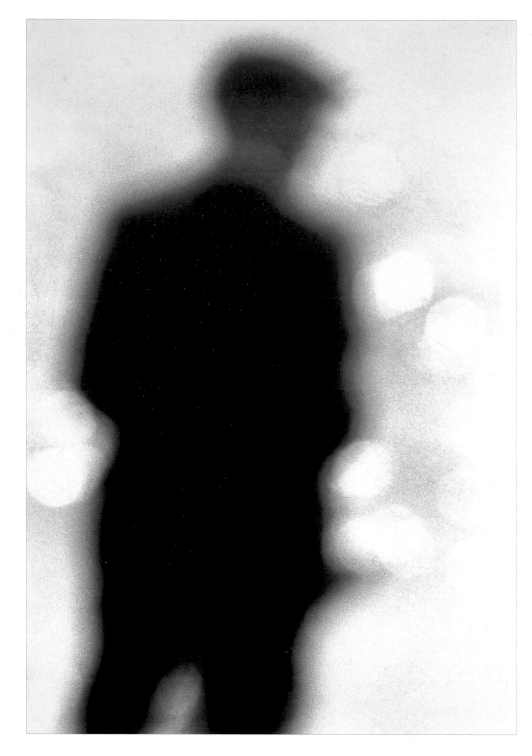

My own favourite photograph is probably the old man, with cloth cap because of the way I have developed since then.

What determines whether I like or dislike a photograph? God knows - maybe that. It works on several levels.

What is my most important sense other than sight? Hearing.

Do I take holiday photographs/fun pics? Yes, they differ little from my other photographs, because I never know when something is going to work visually, and the content is a record of my experiences.

Is there anything about the solitude of being a photographer that appeals to me? Showing what solitude sees.

Is photography about spontaneity or reflection? It is about reflecting upon spontaneity.

previous page:
**Untitled**
A personal image that came out of a project I was doing on astrology - the subject is a Gemini.
The image was shot in a studio, using one tungsten light and a double exposure, moving the light while the subject remained still, just moving his eyes.
The print was made on colour, RA4 paper.

**Untitled**
Another personal image, simply inspired by the moment. I like its reflective quality.
Shot on 35mm, the print was first sepia- and then blue-toned. Ironically, this image is the earliest of the three reproduced here, but it is now the most representative of my present style.

One ignores the urge to create to one's detriment. The graft of photography is a voyage of self-discovery.

A photograph is an expression of my experiences.

A photographic wish is to be truly able to express what I feel.

What role does imagination play in my photography? To imagine the potential of an event as a photograph, or to work back from an imagined image, this is invariably drawn from an aspect of a real event.

Looking involves the eyes. Seeing? The mind.

Who are my photographs for? Me, anyone who likes them; money.

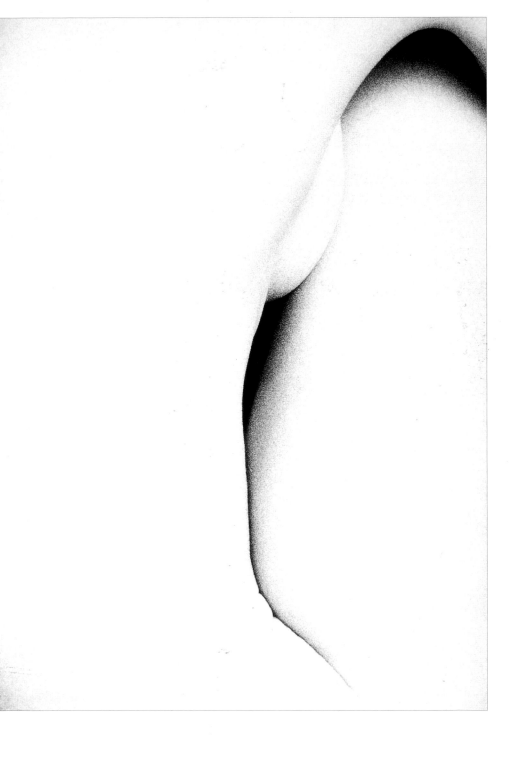

**Untitled**

*The image was inspired by the work of Henry Moore. I like its sculptural, peaceful quality - lit with daylight. It is a straight Record Rapid print. made from a 35mm negative, printed straight.*

# Darlaine Honey

**Status** Amateurish, part-time professional.

**What** else do I do? I'm a multi-tasked, care person. (Housewife, mother.) Also, I paint and think.

**Inspired** to become a photographer by my father. He was a very keen amateur photographer. He and two of my uncles constantly took pictures. He bought me a Boots Biarette camera for my eleventh birthday.

**Learnt** photography mostly by teaching myself. I went to college after my first child was born, to stop me turning into a cabbage, where I did upholstery and photography one morning a week for about six months.

**Who** would I like to learn from? I would love to be a fly on the wall in Bailey's studio. I'd take in the atmosphere. I like his down to earth, basic personality. I want to know how he decides what kind of lighting to use, and his way of dealing with the punter. He has done such a vast amount of work, and every exhibition I see of his, whether I like it or not, has such variety. And he looks like my Dad!

**Favourite** photographers are Man Ray, Bailey, Francesca Woodman, Weston and Jan Saudek. Favourite photograph is 'Glass Tears' by Man Ray, because it appeals to my sense of the surreal. Also, I love a picture that I took of my mother with my daughter, aged one and a half, when my mother was at the end of her life, my daughter at the beginning of hers.

**Best** critics are Dan Honey, Randall Webb and Alex Chappell. Best criticism is 'You don't listen!'

**Aspiration** To capture as much as possible what I originally thought of. (Luck more than judgement, I think?)

### Technique

*I am a total technophobe! I hate technique. My brain cannot absorb it. Take off the lens cap is my rule.*

### Camera work

*I might see the image in my mind before I start, or it might have been a dream that I've had. Sometimes I draw what I think I'm going to do, listing what I need to get - ie props, accessories etc. I buy them, then take them back. I also do most of my hair and make-up, so I have to plan that.*

*Equipment: Pentax Spotmatic and standard lens, Canon 1000fn/500, 28-70 and 35-200mm lenses, Bronica SQAl, plus 80mm lens and waist-level finder.*

*I don't really have a technique. It depends on what I am doing. Usually one light, daylight, daylight reflector and - much to Joan Williams, my friday morning teacher's horror - no hairlight. Joan is a fantastic lady and good teacher!*

*I usually carry a camera. When I don't, it's because I forgot.*

### Darkroom work

*Do I work to a system? No.*

*How do I decide which negatives to print? I just choose the one I think I like and do a test sort of thing. If it looks all right, then I go for it.*

*What print exposure methods do I use? Pardon?*

*What makes a well balanced print depends on the subject - I like plenty of tones. What other qualities do I look for? Any! I am never satisfied with a print.*

*A print might take between half an hour and three hours to produce.*

*Equipment: Meopta enlarger, a timer, and a stop-clock.*

*Technique: go in, load neg, do test-strip, and make print.*

*Do I laugh in the dark? It depends what's on Radio Four or Greater London Radio.*

### Post darkroom work

*I try and print as cleanly as possible, to minimise touching up. For portraits and personal stuff, I might selenium tone or split tone, depending on the subject. I have painted on images, and used mixed-media, but prefer straight prints. Having said that, I do use Photoshop 5, albeit limitedly, because I am still teaching myself. With Photoshop I can have more control over tonality, or I can make all kind of colour changes. When I learn how to use it properly, there will be no stopping me. Technology allows me to explore images more, layer things, mix things together and explore new, more creative, avenues. Images get printed on straight paper first, to see what I want from them, then onto card or photo paper.*

*Post darkroom equipment: Spotone, watercolour paint, Adobe Photoshop 5 and an HP printer.*

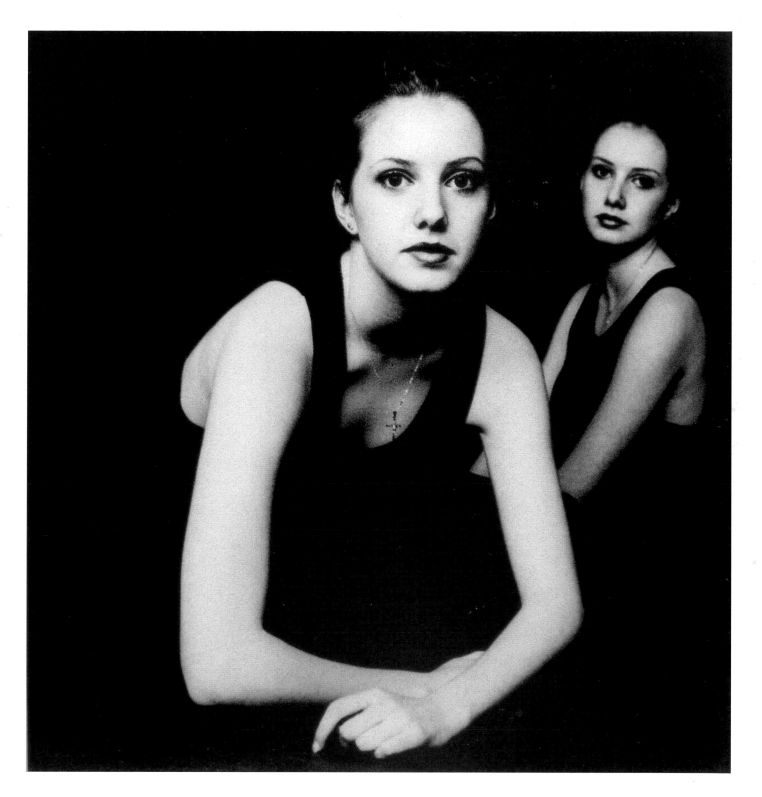

Honey - 2

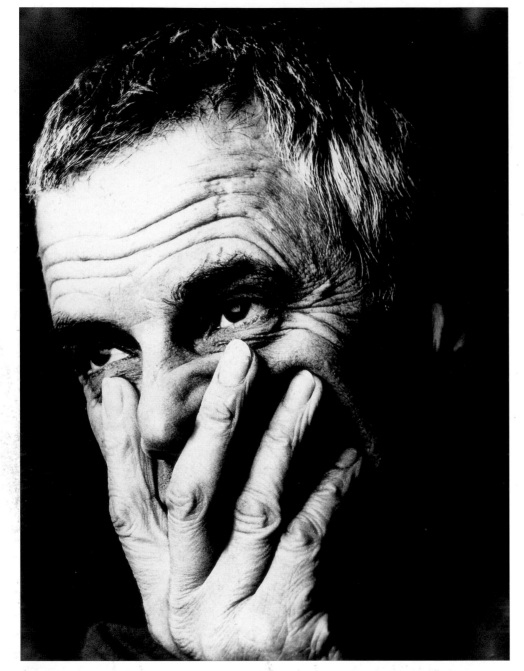

My favourite photograph is without doubt 'Water nymph'. This image appeals to my sense of surreal, and fantasy. I like the idea of being clothed in a swimming pool. I've done quite a lot of shots at this location, which belongs to a friend of mine. It was quite a surreal day as her husband was trying to hold a business meeting in his office, which overlooked the pool, but the female in question distracted their attention. This image is not sold yet. I don't know why. You tell me! It would make a good book or record cover.

I like any picture that makes me stop to look. I don't think I can express very well why I might not like a picture - I just sort of know.

I once went to an exhibition of a very famous photographer, and the main body of work was snaps taken on a snappy camera, but blown up big. They were of the dog, the carpet, next door's cat on the fence - that sort of thing. I didn't like that very much because it was as if the person could put any old thing in, and because the person was famous that was OK. That's not to mean that I don't think it wasn't valid. I just didn't like it.

previous page:
**Twins**
I'd seen the twins at my son's school. It was the second time they'd been asked to sit for a photographer and they're only fourteen.

this page:
**Dan**
The image shows my husband in a rather bad light - we had a lot on! A straight print made on Seagull.

*Other than sight, my most important sense is touch.*

*Looking is for wallpaper. Seeing is something else. I don't know about other people, but for me it is a feeling.*

*My photographs are for me.*

*I love taking holiday pics/snaps, there's no pressure on me to get it right!*

*Is there anything about the solitude of being a stills photographer that I like? Not really, I love people.*

*Photography is both about spontaneity and reflection. Spontaneity captures expression. Reflection captures something else.*

**No title (Time)**

*The original idea was to enter a Samaritan's competition. This was part of a series of four images: time, confidentiality, listen and hear. I photographed onto slide some pages from an ancient dictionary, then projected these onto the subject's face for the final shot.*
*I like the picture.*

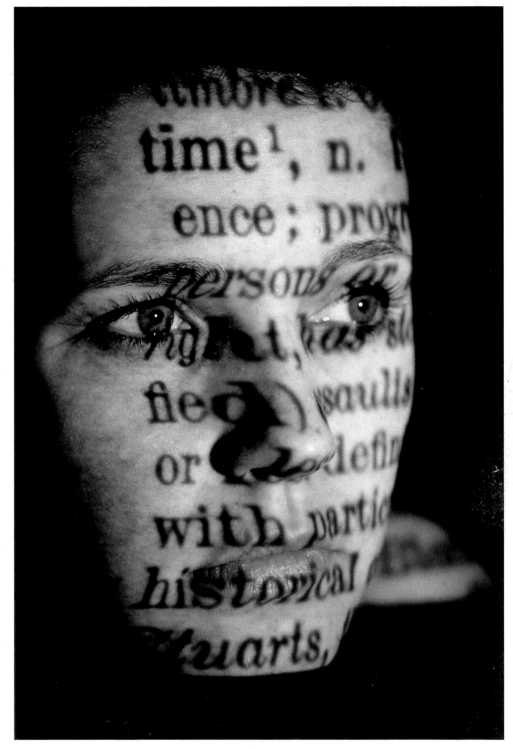

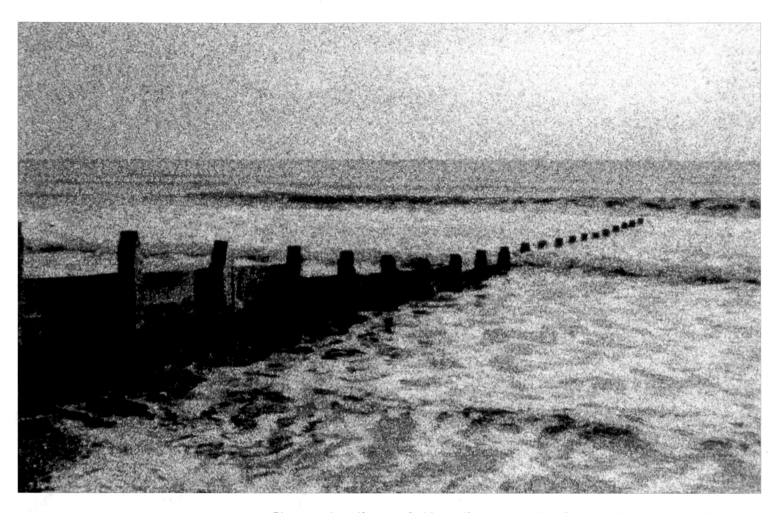

**Breakwater - Hastings**

*A holiday snap, put through Adobe Photoshop, changed to black and white, tinted blue and put back onto slide.*
*I suppose 'cliche' sums up this picture best!*

Photography: gift or graft. It's a gift to see, and graft comes in trying to put it together.

A photograph is a moment in time and a work of art.

People can see whatever they want of me in my work, which therefore depends on the picture they are looking at.

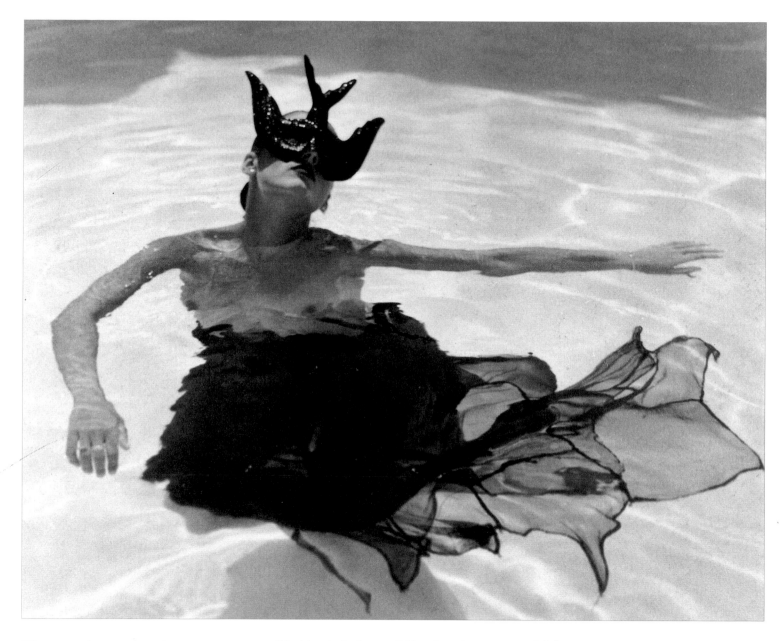

**Water nymph**

*This is one of my favourites - a dream/fantasy photograph. It was shot on 6x6, printed on Seagull paper, and selenium-toned.*

What is photo heaven? How long have you got? A larger studio with lots of outside space, a swimming pool, nice clothes, textiles - lots of different sizes and ages, access to film processors, no art directors, no liggers, Paul Weller, Picasso and my friend Alex to join me.

Imagination plays a huge role in my work.

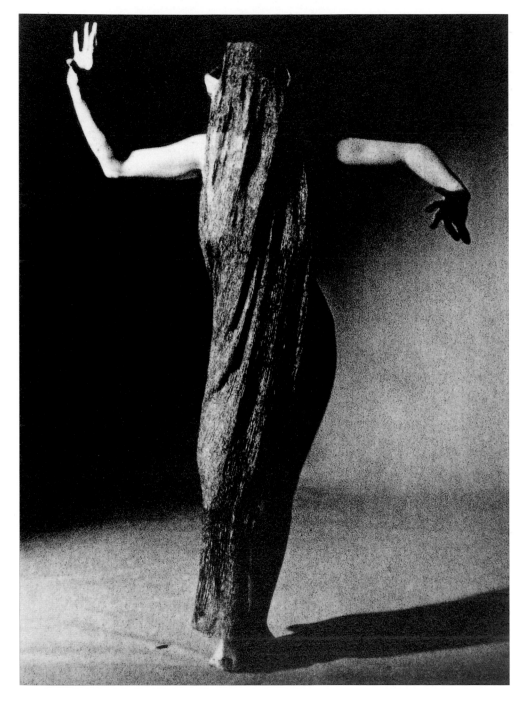

Do I value what others say? That depends who says it, but if it's my personal work, and I'm really into it, I probably disregard it because I don't really care what people say about it. If they don't like it that's fine.

Photography has become an obsession ever since I realised it could really be a career - still hoping to make it as a career.

What have mistakes taught me? That doing it again is a pain.

**No title (Figure study with shadow)**
*I wanted to do some body and form photographs without showing breasts etc.*
*The print was made on Kentmere Art, lith developed. I'm very fond of the image as the sitter is known to me intimately.*

*I wish I could hang out with Man Ray, Picasso, Salvador Dali and their friends recording daily events in the fascinating lives of these people. Also (this is a joint first place wish) to photograph Eddie Izzard, Vic Reeves and Bob Mortimer, Dave Stewart, Frank Bruno, Glenda Jackson, Tommy Cooper and Cerys Matthews from Catatonia.*

*Photography is an absolute passion. I'm quite neurotic without a project.*

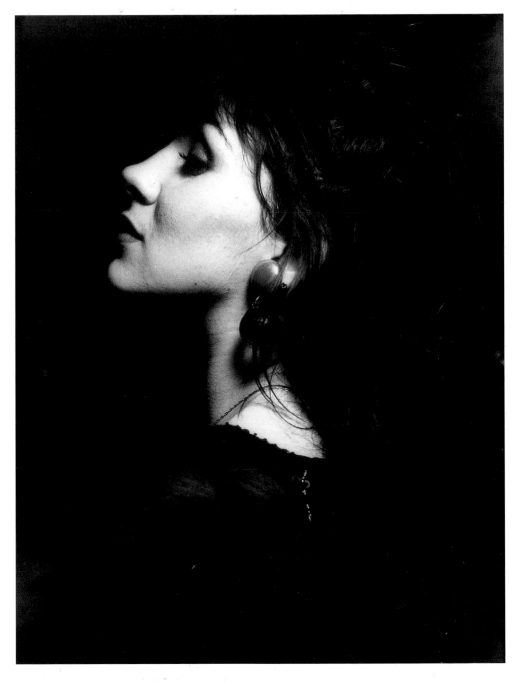

**Treza**

*I was inspired by the sitter's profile. I can't really remember how I made the print - probably on Seagull paper, printed straight with a stocking over the lens. I like the sitter just picked out of the black.*

# Stuart Knowles

**Status** Part-time, semi-professional.

**What** else do I do? I work in retail.

**Inspired** to look at the arts by my sister. Photography was a natural progression.

**Learnt** by going to college, where I received very little help and direction - this proved to be to my advantage.

**Who** would I like to learn from? I see things in others' work that can help my development, but there is nobody that I would set out to learn something from.

**Favourite** photographer is Holly Warburton. My favourite photograph would be anything of hers. She is one of few photographers to go beyond photography and completely alter the medium.

**Best** critic is myself. Best criticism is any kind, large or small. It makes me re-evaluate what I do.

**Aspiration** is to be surprised by the medium. There is nothing more exciting than creating something you don't expect to make.

## Technique

*I love it!*

*To create something from a medium that is new to me is fantastic. However, to rely on it is a mistake.*

*Rules? I would always break them to achieve something.*

*Mistakes are good and have always shown me something new.*

## Camera work

*A camera doesn't give me a view on the world - only my personal world.*

*Do I see the image in my mind beforehand? If I did, where's the excitement? Spontaneity and flukes are my planning.*

*I don't work to a routine.*

*Equipment: the camera is irrelevant. My techniques, so far, have been entirely experimental in the darkroom and with film. They are derived from abusing the film/paper or process.*

*I only carry a camera when I have to.*

## Darkroom work

*Do I work to a system. No. Never.*

*What process do I go through in deciding which negatives to print? I try them all.*

*What print exposure methods do I use? I turn the enlarger on.*

*What qualities do I look for in my prints? Graphic qualities - anything that is unusual.*

*At what point am I satisfied with a print? Printing is only the first stage.*

*A print might take all day to make.*

*Equipment: again I feel it is irrelevant, as long as you have something.*

*My techniques are manipulating the film and paper to see how far I can push them, not in a scientific sense - more like vandalism.*

*Do I laugh in the dark? No, I'm usually too het up.*

## Post darkroom work

*This can involve painting on the image, printing the image again onto colour paper, some bleaching and burning, layering with texture, re-photographing and also distorting.*

*My post darkroom techniques include painting - oils/gauche, treating the print as a still-life, ie re-photographing it, bleaching as far as possible, or printing high contrast black and white film onto colour paper.*

*There's the risk that computer technology will take away a lot of spontaneity and excitement.*

*I am not a perfectionist. (but I wish I were).*

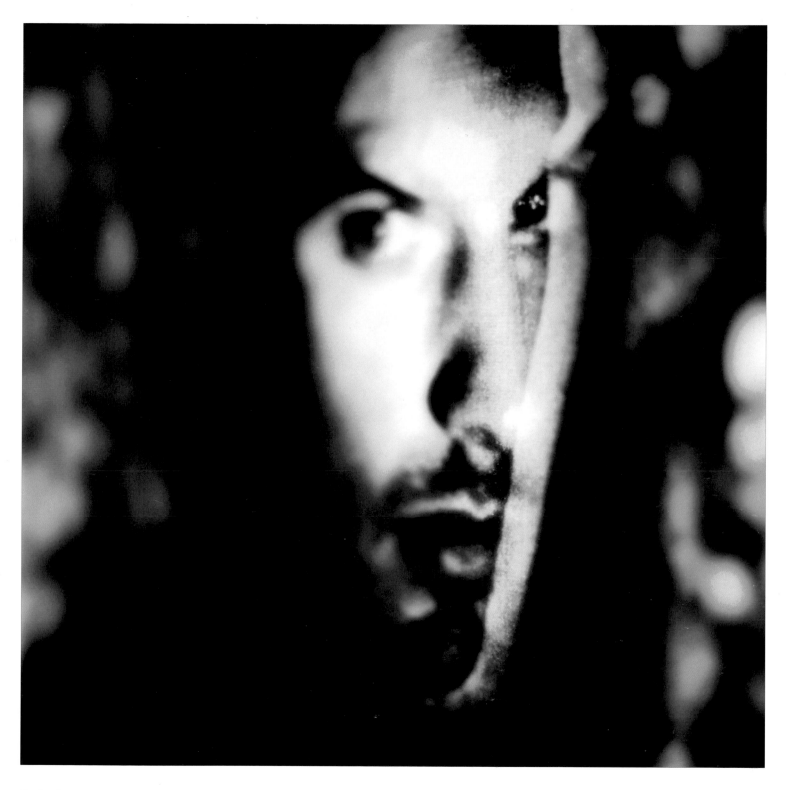

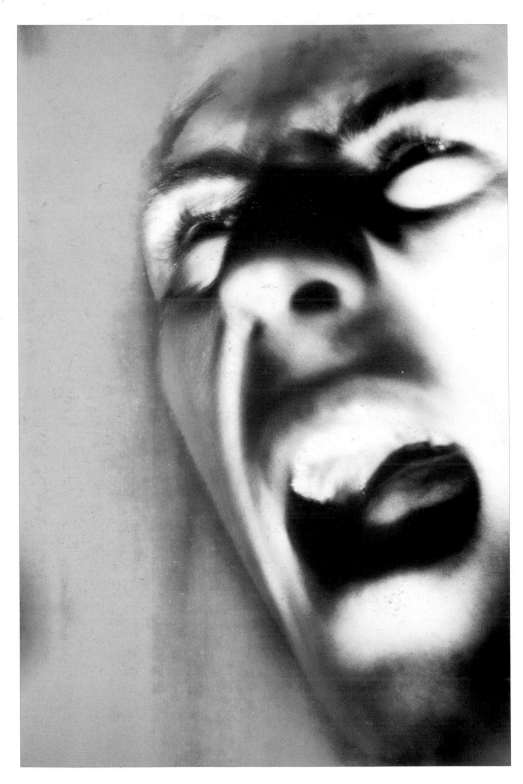

My favourite photograph is always my last. Does this make it my most successful? No, especially if isn't commercial enough.

What determines whether I like a print? It depends on what it communicates. The picture must 'Affect you', not just by a technique, but by what it portrays. You must be able to understand the emotion in the picture or in the photographer.

previous page:
**Untitled**
The inspiration for this picture was me trying to be more commercial. I re-photographed a print as a still life, trying to take it further away from what it was. The final print was made on Cibachrome. How would I describe this picture? Just a portrait.

this page:
**Untitled**
A commissioned photograph, but it wasn't used. The inspiration was the book 'The Comforts of Madness' by Paul Sayer.
It's probably my most successful image, even though it looks a bit outdated (seventies-ish).

Apart from sight, touch is my most important sense.

To look is to view, to see is to understand.

My photographs are for me mainly - but I need them to be appreciated by other people.

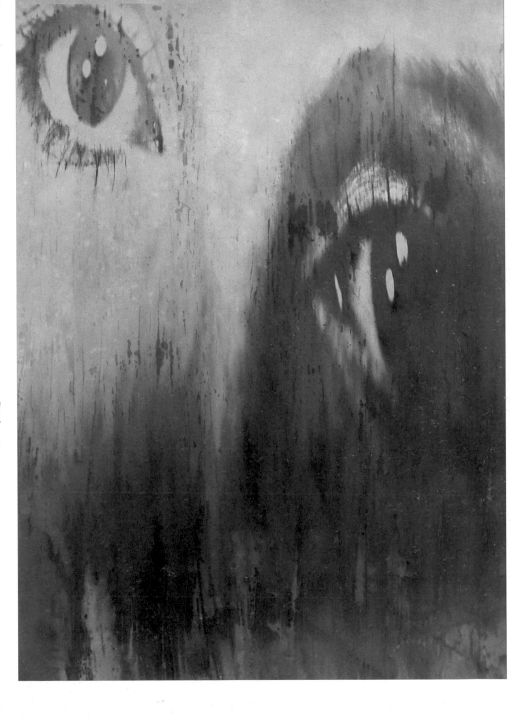

**Untitled**

*A personal image inspired by a friend of mine and the work of Krzysztof Kieslowski - looking for a transcendental quality.*
*Lith film, printed onto black and white paper, bleached and toned. I find the image very haunting.*

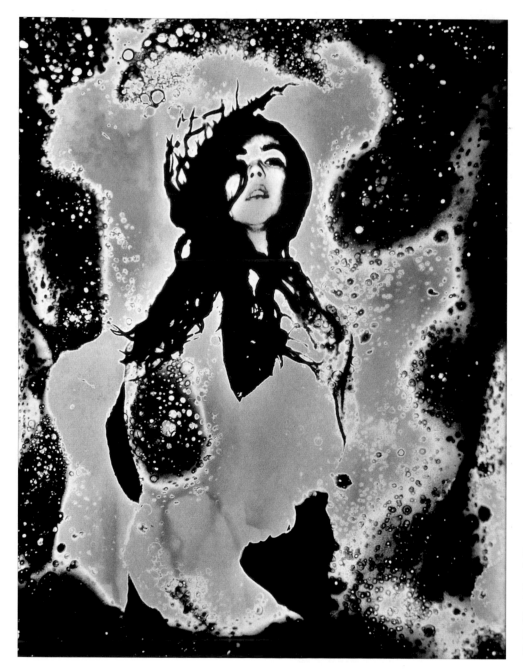

Do I take holiday photographs? No! I hate being a holiday photographer. I only use photography to achieve what I would be unable to paint.

Is there anything about the solitude of stills photography that appeals to me? Yes - and that's why I only choose to do it part-time. The solitude gives me the opportunity to put more of myself into my pictures. However, at the end of the day we need to get a life!

**Untitled**

The inspiration for this photograph was the power of women. It was a personal image.
The original transparency was burned, copied onto black and white film and then printed.
I would like to make the image again - I feel it's incomplete. But it's too late now.

*Spontaneity is to create. Reflection is looking at why you created it.*

*For me photography is a graft - I couldn't be a commercial photographer - brain surgery is easier.*

*A photograph is personal expression.*

**Untitled**

*I wanted to reflect the male psyche.*
*The lith image was fogged, with texture transferred on to it. The print was then toned, with bleaching. I feel it communicates what it was supposed to.*

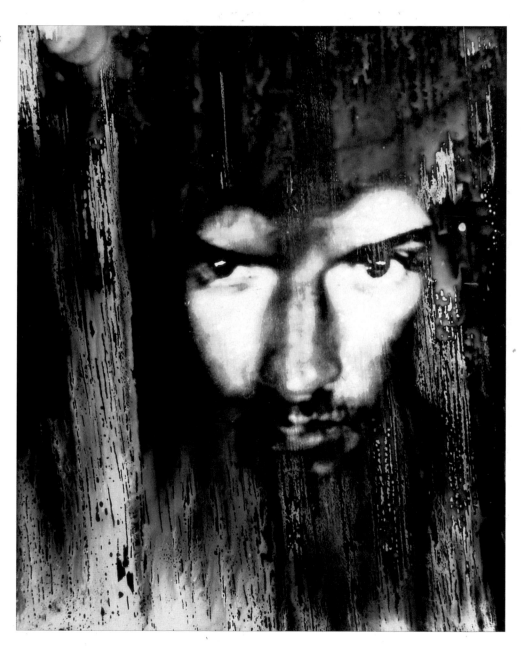

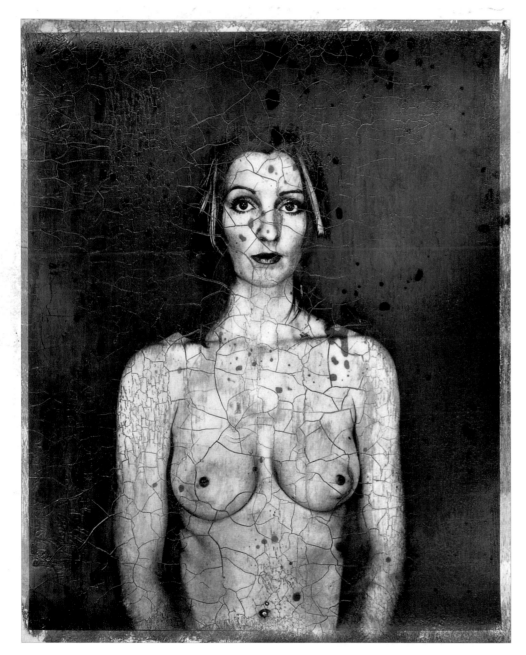

*What can people see of me in my photographs? That depends on how deeply they look. Quite a lot, I would have thought.*

*Photography is an essential part of my life.*

**Dawn II**

*This image was inspired by Dawn and how she perceived herself.*

*The lith black and white image was printed on to film and painted on with oils and a cracklelure coating.*

*This is one of a series of four images. I like them all very much. They reflect Dawn honestly at that time.*

*A photographic wish? To be a lot better.*

*What role does imagination play in my work? Not enough. It's very hard to create what you imagine. Once you can do that, you've got it sussed.*

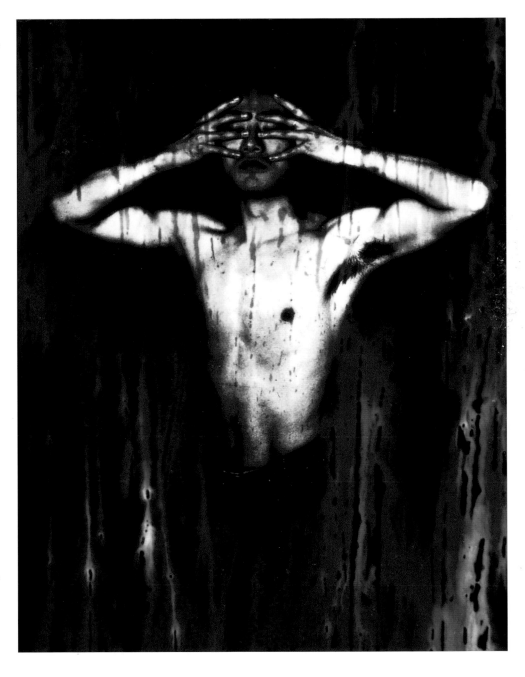

**Untitled**
*A personal photograph inspired by the human form. The original was shot on lith, which I manipulated, transferring texture on to it and then fogging it. The print was made on colour paper.*
*I feel the image is incomplete.*

# Richard Lewis

**Status** Full-time professional.

**Inspired** to become a photographer by music and the artwork of V23, Vaughan Oliver (in the early days).

**Learnt** photography at university - experimenting, not through books.

**Who** would I like to learn from? No one who is alive today.

**Favourite** photographer? Arthur Tress; the only genius photographer - very under-rated. Favourite photograph? I don't have one; I like Dali, Magritte and Francis Bacon. Generally I dislike 90% of photography.

**Best** critic is Verity, my girlfriend. Best criticism? I couldn't say that any criticism has done anything for me. I have listened to advice, but I have to respect the person who is criticising me - otherwise who the hell are they! I say: 'If you don't like it, don't look at it'.

**Aspiration?** Not selling out, no compromise (no bullshit), and no reportage.

## Technique

*Technique makes photography worth doing, even if it's not worth doing again. Techniques evolve because of this.*

*I don't follow any rule.*

*I love the unexpected*

*Mistakes teach me new techniques - they move me forward.*

*If you are truly creative, it has to be a gift.; if you are a technical photographer, it is more craft.*

## Camera work

*The camera contains my view of the world.*

*Do I see the image in my mind before I photograph it? Yes, but I let it develop as I work on it, to take the idea/image along different paths and to see where I end up.*

*I have no routine.*

*If I did have a routine, it would bore me stupid and it would reflect in my photography.*

*I have to love what I am doing.*

*Equipment: Hasselblad 500 CM, a Metz flashgun. and any form of light.*

*Do I always carry a camera? No.*

## Darkroom work

*I don't have a system - that would be too easy.*

*How do I choose which negative to print? I look at the contacts and choose the best one - normally the image which is rawest.*

*I always guess the exposure - I never take a reading.*

*What determines a well balanced print? Depth of colour and atmosphere/ambiguity.*

*What other qualities do I look for in a print? No fingerprints and full borders, and no cropping.*

*At what point am I satisfied with a print? As soon as possible.*

*How long might it take to make a print? One to one and a half hours, sometimes five minutes.*

*Equipment: I hire a lab in Brixton.*

*Do I laugh in the dark? When I make mistakes..*

## Post darkroom work

*Nothing - I print straight from the negative.*

*What new opportunities has computer technology opened up? For me, personally? Nothing but a challenge - I don't even know how to turn one on.*

*Imagination is everything.*

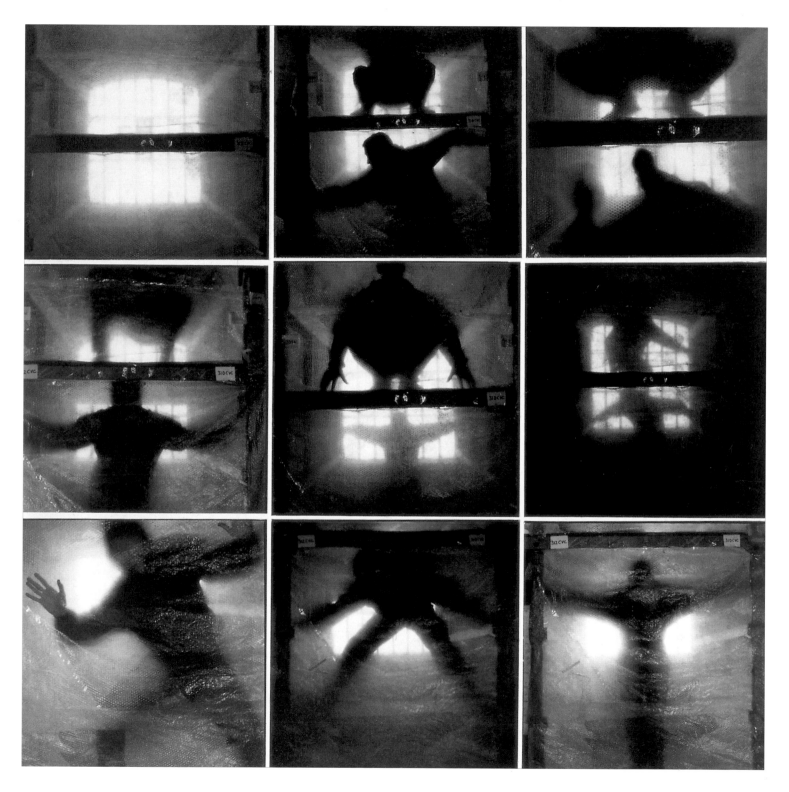

Lewis - 2

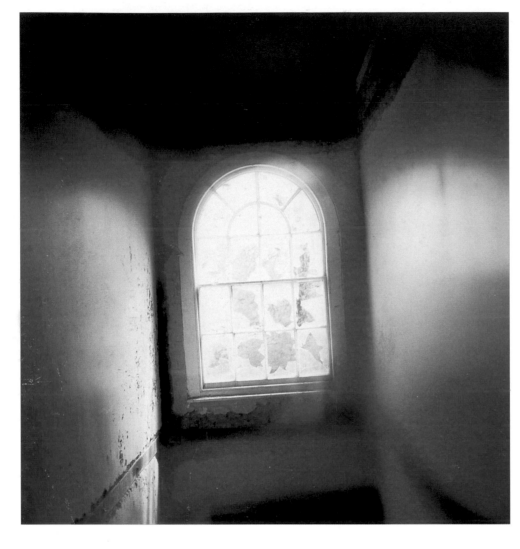

I don't particularly like any of these images because they have been around for five years. However, I don't dislike them, but they are all instances in time (in my life) when I was thinking differently. I suppose I have just seen them too often - they are a part of me, a part of growing up and learning about the medium - I was only playing around at the time!

I suppose the blue chair shot is the image which I respect the most, as it was a bit of a milestone in my personal photographic technique and development (I have just been overly involved with them for too long) - I like them all really!

What determines whether I like an image? It has to be aesthetically pleasing to the eye. Something not straight - it has to be quite dark with a twist.

*previous page:*
**Confinement C16**
*This is my view on life - a human bee-hive, showing claustrophobia. I was inspired by an empty, unused space and the idea of making something from it with just a few pieces of wood.*

Is photography about spontaneity or reflection? It's about both - one then the other.

*this page:*
**Untitled**
*This isn't one of my best photographs. It's a bit simple but quite pleasing, with nice lighting and good colour - but not provocative enough. I was trying to show the fear of being alone in an asylum.*

A photograph is something personal and created from imagination, not just point and shoot - anyone can do that. It has to have style and a personal element.

*What is my most important sense other than sight? A sense of humour - you need one in this business. There are too many jokers around.*

*Seeing is obvious. It's more fun to try and find out what a picture is trying to portray emotionally - not necessarily what it looks like, although it has to look good.*

*My photographs are pure self-indulgence - therapy.*

*Is there anything about the solitude of being a stills photographer that appeals to me? Yes, I can escape and create wonderful ideas/images to get away from the day-to-day mundaiety of life.*

**1999**

*The picture was inspired by the Heat Miser song, 'Tricky'. I like the way the image shows beauty within dereliction - look beneath the surface! The shot was made with a long exposure; it was freezing cold and my camera filled up with water. I love it. It could never be repeated. It's a one-off.*

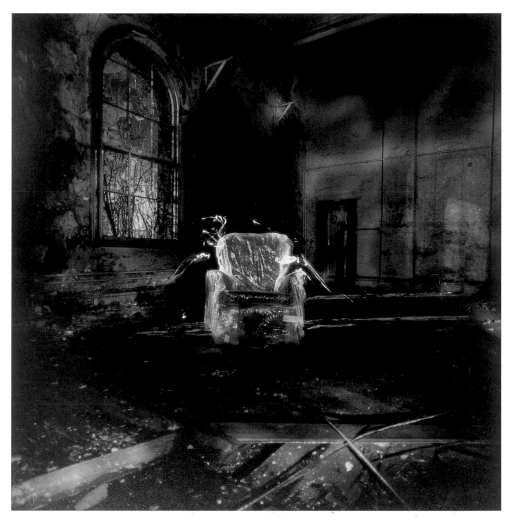

*What do other people see of me in my work? Ask them - I see contradiction (darkness).*

*What does the phrase 'photo heaven' conjure up? Hell! Lots of photographers. Hell!*

*If you had a photographic wish, what would it be? Respect.*

# Alexandra Murphy

**Status** Professional; full-time in my head and part-time in the week.

**What** else do I do? Part-time bookseller and part-time photography teacher in community education.

**Learnt** photography by choosing it as my major. I felt it more of a challenge - it being an unknown area to me. I scraped into university, completed a four year bachelor of fine arts degree in Photographic Arts which led to a masters degree.

**Inspiration** I used to draw and write a lot, but have sadly, of late, not been able to apply myself due to time taken up working. All the spare time I do have is dedicated to photography. Photography is a passion; it scares me to wonder what life would possibly be like without that constant observation and out on the edge aspect of recording it.

**Who** would I like to learn from? As egoistic as it sounds, I wouldn't really want to learn from anybody. I would like to be a fly-on-the-wall and watch my favourite photographers in action, just to see how differently they approach their subjects.

**Favourite** photographer - I don't have one. Those I do favour appeal to me because of their individual eye and technique: Lee Friedlander, Cindy Sherman, Cartier-Bresson, Paul Graham, Jan Saudek, Eugene Smith and Dave McKean. A favourite photograph? That is a difficult question, because there are so many good images out there, all saying different things.

**Best** critic is a friend of mine, who I consider to be acutely intelligent and somewhat of a genius in his own right. He says that a lot of my work is rather pretty! I like the female aspect of my work when it appears, but 'pretty' is a bit much for my liking. I do see his observation and I am critically aware of that aspect of my work when I produce new images.

**Aspiration** to have the opportunity to work on personal projects full-time and to be able to live off the financial results.

### Technique

I sometimes hate it because I am not a perfectionist and technique is the perfectionist's tool. I love it when it works for me: certain lenses, printing techniques, framing methods and good use of composition.

### Camera work

I usually wake up (on a 'free' day) and know that today is the day that is right to shoot a particular image. I get a loose idea in my head, an association of moods, which I then try to express/shoot. In black and white I uprate Tri-X film to 800ASA (I love grain). My choice of colour film (slide/neg) depends upon what I intend to do with it.

Equipment: 2X 35mm Pentax bodies - MX and MZ-5, 70-200mm f4.5 Pentax lens, 28-70mm f2.8 Sigma lens, 18mm and 24mm Pentax lenses, a Nissan flashgun, Cokin filter system, TLR Rolleiflex and a Polaroid camera.

I always work close-up to the subject hence the wide angle lenses are my favourite, especially the 24mm. Favourite filters are deep red and orange. I only use my Rollei for set-up shots - and then not often enough, and the Polaroid only for specific projects.

I don't carry a camera when I have a busy agenda ahead and I know that my head won't be in the mindset for it.

### Darkroom work

It plays a huge role in determining the image.

I always get any contact sheets over with ASAP as I can't stand printing them (but find them very helpful for reference). If I am still unsure what images to print I make 5x4" work prints.

I always print on FB paper and usually with a key-line border.

I make lots of test strips. I consider myself fortunate if the first print is right. I use tongs for tests and fingers for final prints. I get paranoid about marks and stains occurring on prints - photography can be so fiddly! Hence, print washing takes ages for me.

Equipment: Cromega D 5x4" colour-head enlarger with interchangeable lenses, negative carriers and condensers for 35mm, medium format and 5x4", four easels for different formats, various negative masks and dodgers

### Post darkroom

I retouch marks and tone in daylight (usually sepia and blue). I am improving my computer equipment to explore digital manipulation.

Darkroom manipulation is still of value - both result in different effects. I am very interested in exploring this new medium, as it will open up a different way of seeing for me in terms of putting an image together.

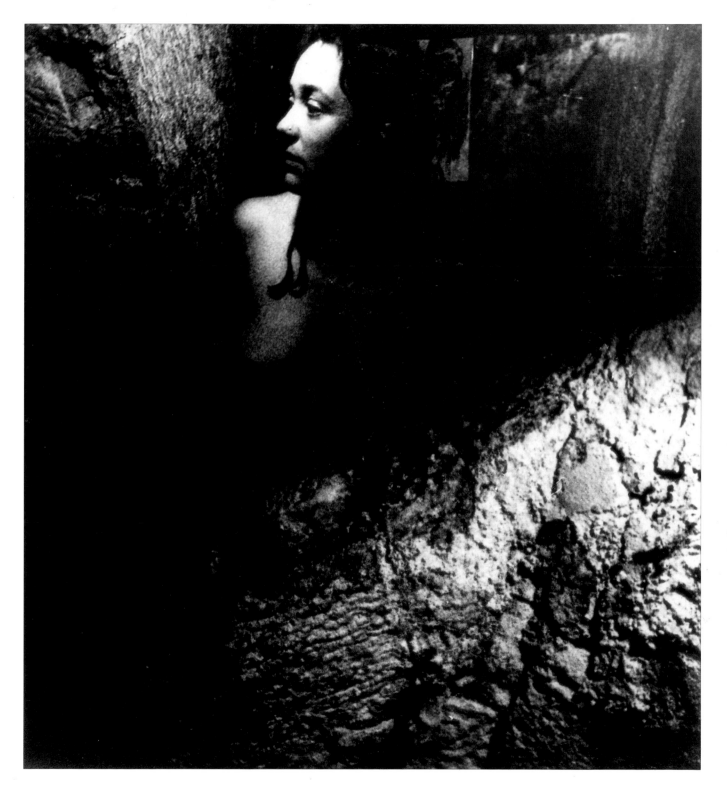

A camera opens up the world - by focusing/isolating what is seen through the lens, it feeds me a fascination of rediscovering elements that were often right under my nose as well as discovering something completely new to me.

What makes a good print? A clean velvety quality, deep blacks (not washed out dark greys) and whites that don't glare too much. Grain also has to be clean and sharp. Also I don't like printing faults like dodging and burning-in marks, unless they are used creatively for visual effect.

If the grain isn't of a clean and clear quality then I usually end up disliking the image. I actually can't remember if I have ever laughed in the darkroom - cursed plenty, but never laughed. I have chortled to myself upon seeing certain negatives but even that is rare.

previous page:
**Aeon**
A personal image, inspired by the cellar I was in at the time - the texture of damp rock and skin. I think it speaks of ages, in the feminine sense. The HP5+ negative was uprated to ISO 1600 and then sandwich-printed.
I like the image. It is elusive and visually gentle and yet in terms of my manipulation techniques it has an unusual rough edge to it which I really enjoy.

It takes three, maybe four hours to make a print depending upon its size, the amount of manipulation to be done and how much research I've done, i.e making work prints.

opposite page:
**Introspection**
The manipulation dictated the mood of the image. The inspiration was to attain a womb-like feel, that floats yet is weighted by its introspectiveness. The negative was sandwiched, handcoloured and colour printed onto colour paper with filtration. I like the texture of the picture. I feel the techniques I used to attain the mood have been successful.

A photograph is an individual's energy and insight into this madness and monotony of living!

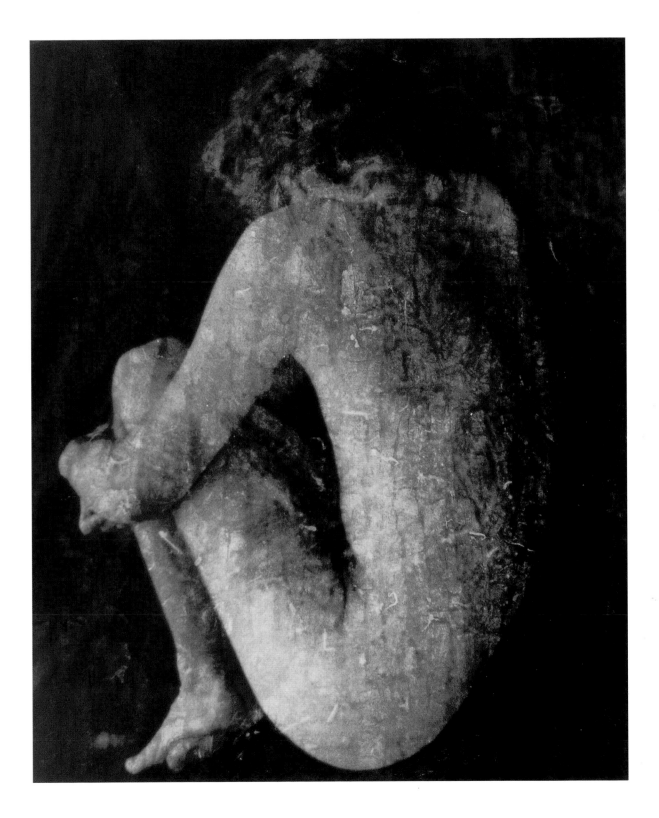

*What can people see of me in my work? Not much, I think. The problem with regarding the artist through their work, is that if one likes the work, one tends to idealise that person/artist. The work weaves an aura of mystery and wonder around the artist, which is totally misleading.*

*I believe in following the rules of simplicity, even with manipulation. Going overboard or becoming too 'heavy' with content/meaning or technique reduces the power of the image. If it is simple it should slip underneath the guard of the viewer to achieve a better visual and visceral impact.*

*Mistakes keep me grounded, which I hate, but I think this is necessary to keep my work and myself intact with life, unfortunately. I mean who in the hell enjoys making mistakes?*

*opposite:*
**Skin. Rock**

*I was inspired by the rock, the light and the space of the location. I think it is a classic-type shot of a nude.*
*I used Tri-X uprated to about ISO 800, shooting with a deep red filter. The print was sepia-toned. Personally, I find the image visually pleasing. It captures the mood that I was hoping for at the time. However, I do find it a bit too 'pretty' and rather slick in its manipulation.*

*It is the balance between imagination and reality that gives rise to concrete creativity. So, yes, a great deal of imagination is responsible for my work. I used to believe I was a just a medium/host for this creative force inside. I just couldn't understand or accept that this creative energy was specific to me. Now, I just think it is what I said above - imagination and reality through life experience (age, getting older, life experience whatever, fuels that imagination which allows for change in one's work which is marvellous).*

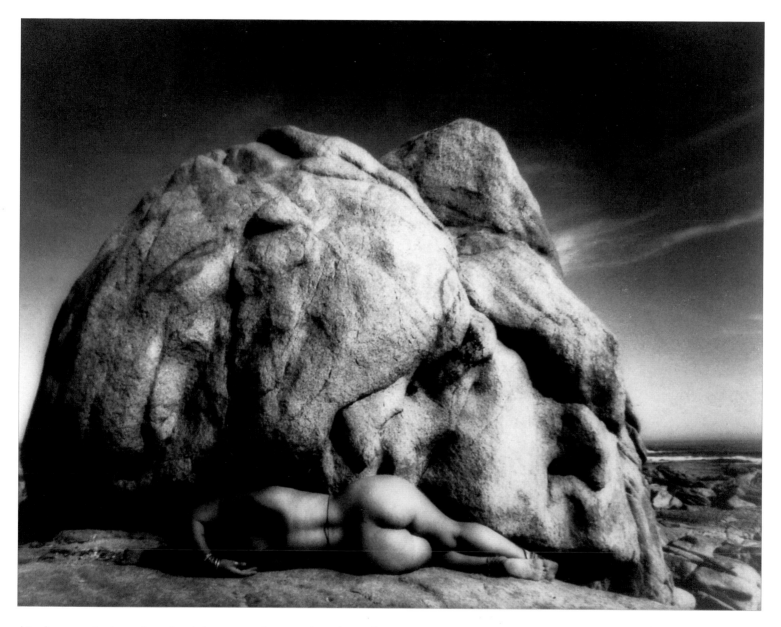

I tack up contacts and work prints on a wall somewhere in my house, where I can study them until some kind of decision comes to me. During printing, tests are stuck on a wall or door next to each other, as I need a little distance for viewing, particularly with colour printing when I manipulate the image with dyes and filtrations.

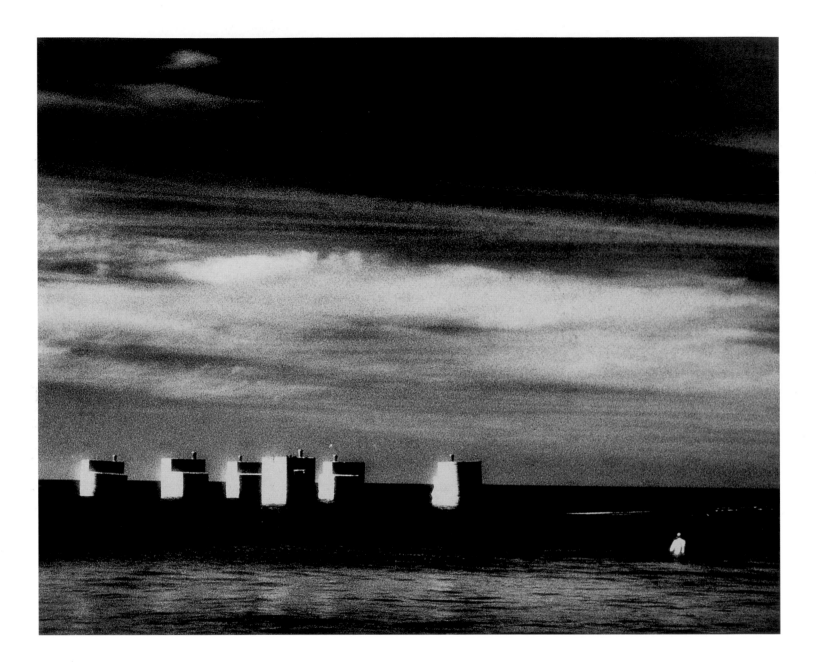

At times I simply don't wish to carry a camera around as it bears its own 'weight' and responsibility.

I'll break my own rules when I'm angry and I want to show that in my work - pure self-indulgence!

**Presence**

*The image was inspired by the moment. It was shot on Infrared. The print is conventional. It needs to be printed quite large - otherwise it loses its impact. I love it when I find myself in the right place at the right time, hence my enjoyment of the image.*

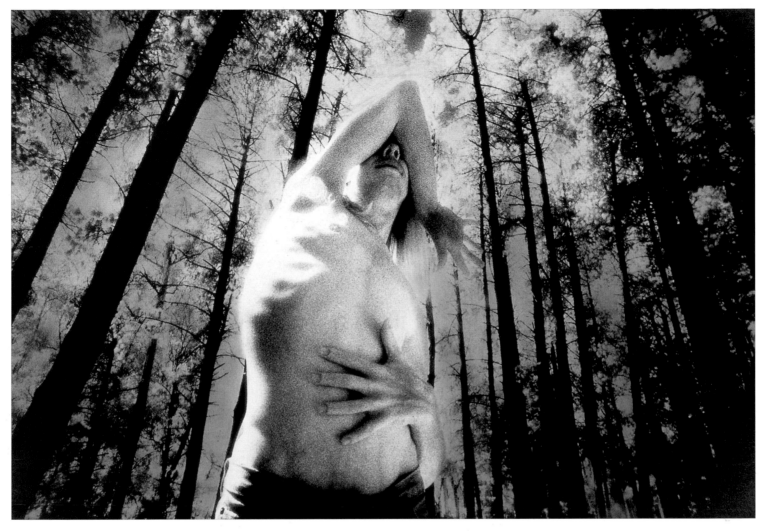

**Shelter**

*An image inspired by the forest I was in, the way the light was filtering through, the person I was with and the film I had in my camera. I feel it conveys shelter - nature's presence.*
*I used Infrared film. The black and white print was sepia-toned and hand-coloured.*
*I feel the angle of view and the dreamy feel of the image make it work.*
*A pleasant memory.*

*A photographic wish? Give me the freedom to travel and work on my photographic projects. That would be wonderful.*

# Joseph Ortenzi

**Status** Professional.

**Inspired** by the 'magic' of the medium. My first photo was of my mum and dad on holiday, when I was four and a half (my first lesson in image blur as well!)

**Learnt** photography by working with it, experimenting, and through library books, notably the excellent Time-Life series.

**Who** would I like to learn from? I find it difficult to narrow it down to one photographer as a prime source. For example, now I am interested in portraiture and look to photographers whose images I like on that level. I would like to meet a mystic in the American desert to teach me about seeing… Frederick Sommer perhaps.

**Favourite** photographer? I could produce a massive list based on who I like now and liked through history: in no particular order… Jeff Wall, Diane Arbus, Walker Evans, Robert Frank, Henri Cartier-Bresson, Bailey, Sally Mann, Avedon, Caponigro, Joy Gregory, Sam Taylor-Wood, John Hedgecoe and Ansel Adams (he knew his materials!). Favourite photograph? A Sally Mann; I can't remember if it is of Virginia - a small girl, being so unselfconscious. To me it is about being young and unaware, the way only kids can be.

**Best** critic? Time. There is nothing like repeated viewings to allow an image to make a deep impression on my work and myself. Best criticism: 'Have a beer before photographing… less tunnel vision and see a bit wider'.

**Aspiration** To express an idea simply. To evoke an emotion or understanding. To look at something intensely and intently.

### Technique

*I both love it and hate it. sometimes, when the materials just don't bend the way I want them to. It can be very frustrating, particularly when I get close, but not close enough. Rules are for understanding and breaking.*

### Camera work

*The camera does frame my view of the world. It has a determining influence, eg Velvia versus Polaroid type 55 requires different methods.*

*Do I work to a routine? Only commercially. Otherwise, for personal work, I try to give as much time as possible to the project at hand.*

*Equipment: Whoa! Too much! I'll just describe the camera and techniques used for these photos here. The camera is a 1940's Crown Graphic, a relative of the Speed Graphic camera made famous as the pressman's camera in Hollywood black and white movies. It has a 150mm lens that does most of what I need a lens to do. My technique is simple - avoid distractions, see carefully, and work quickly.*

*I don't always carry a camera. But I have done so, at times in the past. Lately it has been competing with having to carry a laptop as well.*

### Darkroom work

*No system, but I do like the darkroom tidy and well managed. I keep a description of all my recipes, printing and processing in a perfect-bound book.*

*First I look at contact sheets, then view the negs and use one with sufficient shadow detail. I look through old contacts to see if something catches my eye. I 'assess' the neg under the enlarger as it is easier to see it all.*

*Print exposure methods? Unless lith printing, I try to keep the lens two stops down and use an exposure of around 10 to 30 seconds.*

*A well balanced print keeps the eye held within the print and wandering around the subject(s). At what point am I satisfied with a print? I can't tell until it is dry and stuck to my 'plain white wall', for final viewing. That's when I can truly see if I have missed some quality or other.*

*Equipment: Omega 5x7 enlarger with a colour head. I still wash prints in the bathtub, with a combination of syphons and trays.*

*Do I ever laugh in the dark? Yes. Usually it is a whoop of pleasure when something is working out well, or if I see a negative I forgot about trying.*

### Post darkroom work

*Occasionally I print to scan and import into Photoshop.*

*I am looking for a method to output at high resolution onto Polaroid type 55 so I can take my digital work and print it back out on conventional silver-based photographic materials.*

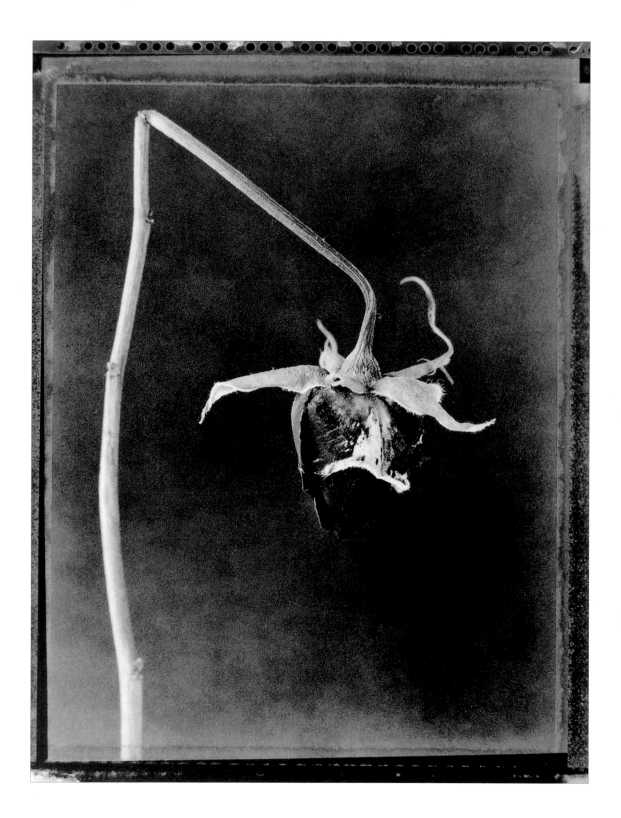

*My own favourite photograph is 'Bent Rose': an idea expressed simply. Most people berate me for photographing 'dead' things, but I find fragile beauty need not be limited to fresh, new blooms. I often parallel my work with a full appreciation of the seasons, which includes the death and decay of winter. Death cannot be separated from life itself.*

*If we refer to successful as being an image that inspires hesitation - and a desire to continue looking at it, then I would have to say that 'Bent Rose' is successful for me.*

*I have to limit my choices otherwise I am constantly working out the differences.*

*I am thankfully still in awe of the photographic process. I always retain elements of fear and excitement, between finishing and seeing the processed results these thirty two years later.*

*Photography is an essential part of my life. I find it very hard not to look at images of any description. Images capture my attention all of the time, including ones in my mind; to the dismay of friends on occasion.*

*Being in the darkroom is not a sacred area to me, nor is it a dungeon. I usually print for long periods of time at a stretch, until I am unavoidably interrupted or too tired to continue.*

*Breaking rules is another way of saying that you are experimenting, and who would deny experimentation as a creative process? I suppose I break them whenever the mood strikes me to.*

*previous page:*

**Bent Rose**

*A personal image, inspired by a tiny rose (this is almost a 2x magnification) that I rescued from the garden, which I kept on my desk for months before approaching it with a camera. The red reduced to a very deep colour, which I imagined would have a luscious shadow density and beautiful texture when printed.*
*The print was made on Process Supplies lith paper, contact printed and lith processed with a minimal amount of exposure manipulation.*
*The picture still moves me many years later and still retains pride of place at home.*

*opposite page:*

**Jules**

*A personal image inspired by the model, her shape, my love for her, her unusual hatred of her own feet and an appreciation of the photographic process. I see the image as a skin pear: fruity, ripe and smooth.*
*The image was printed on Process Supplies lith. It was a doddle to make, except for burning in a bit of distracting, exposed background. Although the image has many precedents in the history of photography, I still feel 'personal' about it as an example of something subtle, simply expressed.*

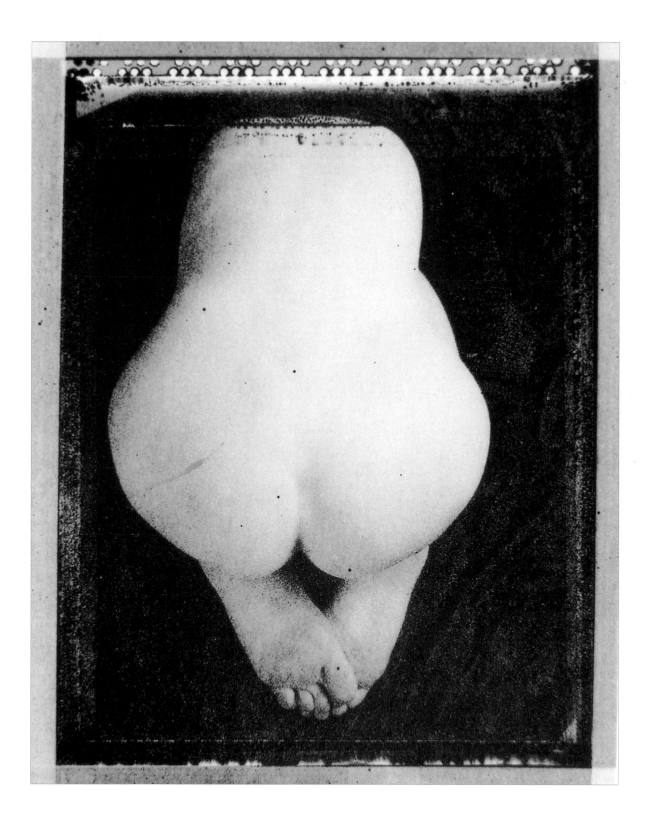

Planning is inorganic and an attempt to carve in stone. Personal work is organic, unstructured and free-form.

What determines whether I like an image? Another layer of meaning that I wasn't initially aware of, even years after first seeing the image, even if I thought I knew all about it. There is often more to see and appreciate.

My most important sense other than sight? It must be touch. It is a strong communicator, and can be visually expressed in a rich way.

Looking is more mechanical, more about quickness and surface, about glances and affirming your own beliefs. Seeing involves more distraction and abstraction, more intensity and discovery. Looking is about statements and seeing is about questions.

Am I a perfectionist? Yes, I definitely can be. I have felt images were 'failures' if they didn't create a strong enough impact. I have often returned to old images with a new paper, for example.

Once you begin being creative, you have the opportunity to express a creative quality to all that you do.

**Clustered**

*A personal image inspired by the subject, its textures and shapes. At the time, when in need of mental stimulation, I wandered out into the garden, or looked around the flat for interesting shapes and subjects to scrutinise through the lens.*
*The print was made on Kentmere FB, lith processed.*
*I like the image better now than when I took it and printed it. I have discovered much more in it since.*

Except for a few rather pedestrian commissions, most of my images are almost exclusively for me. Now whether I choose to supply them to a library, or sell them as fine prints, or sell them in some other capacity, the initial image was sparked by my desire to look at something in a particular way, and retains that focus throughout.

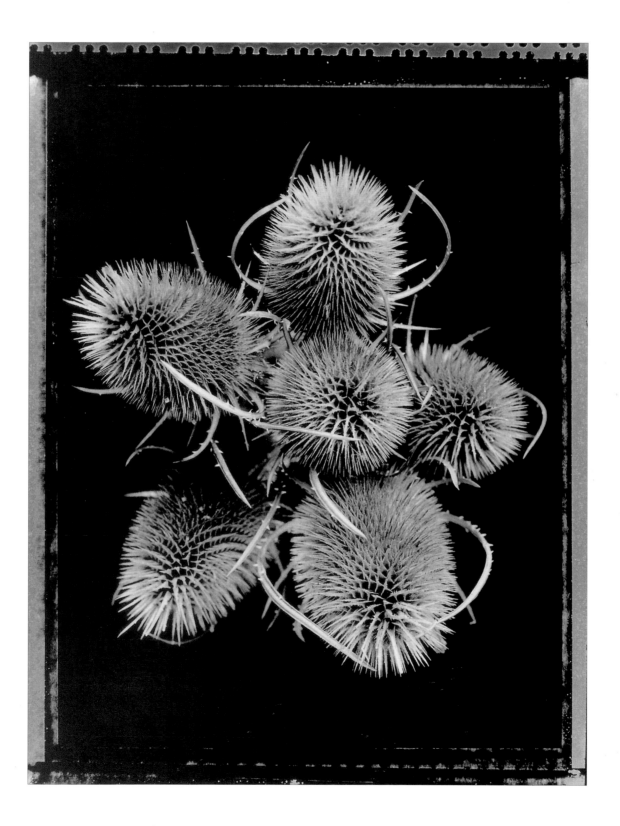

In college I studied Film. At times I found it like 'design by committee'. I could only really appreciate directing or photography or lighting. A stills camera allows me to look inwards more than on a film set. Everything I look at makes me question how hard I want to see it, and why.

Photography is about reflection. The original photographic reaction may happen spontaneously, but a photograph, a good one, isn't complete after the shutter has closed. The reflection you get in the darkroom is an element of the creative picture-making process. Looking at your print, days later, gives you an insight into what it was that you recorded and what you wanted to express with that.

Photography is a graft. Yes, some are naturally gifted, but if they continue to make images, it is a commitment to that process that is the creative quality to respect; not just their 'eye'. A true photographer, who produces lasting images, has got there by their love of the process and by constantly learning about their own approach. Working at it, in other words.

What can people see of me in my photographs? I think I am in there somewhere, sometimes right on the surface or as a subject, but always connected. I suppose it shows when I am trying to be clear.

A photographic wish? Unlimited time, and exactly the equipment I need at the time to achieve my aims effectively; or does that remove the challenge.

Imagination is the force that tells me it IS possible.

Mistakes teach me what to try next time.

**Rose Cluster**

A personal image that followed from 'Bent Rose' as I wanted to place other rose shapes alongside the original subject.

The print was made on Process Supplies lith. It was virtually a straight print, although the subtle tissue paper texture was lost with the process. I did try some burning in, at the centre of the image, to varying degrees of success.

I still like the picture, but not as much as the simple 'Bent Rose' which chronologically preceded it.

# Dean Rogers

**Status** Full-time professional.

**What** else do I do? I have a huge interest in books, film and art - amongst other things; therefore many aspects of my life are creative.

**Inspired** by travelling and my experiences in other countries, film, people and many other things.

**Learnt** photography initially the self-taught way. I then went on to study for five years: a foundation course, followed by a Degree.

**Who** would I like to learn from? Five years ago I would have said Alfred Stieglitz, Paul Strand and Joel Peter Witkin, whom I still greatly admire. Now I feel I would learn more from artists such as Nick Waplington and Andres Serrano, as their work is more relevant to mine and of more interest to me now.

**Favourite** photographer - as above. Favourite photograph? I find this impossible to answer. I cannot determine what makes me like or dislike pictures; each evoke different emotions in me. I draw inspiration from all manner of images, for so many different reasons, not just because of style or content.

**Best** critic is probably myself, as I do expect to get the best out of my work. I always value other peoples' opinions and would never disregard what anybody has to say about my work, whether they be good or bad.

**Aspiration** is to convey the mood I'm after.

### Technique

*I greatly enjoy the diversity of photography and the different techniques I can use to achieve my end result.*

### Camera work

*I use the camera as a tool to express myself. As such, I do feel that it opens up my view of the world.*

*I often have an idea of how I want my photographs to be and I'll make tests and preliminary sketches, but I am always open to unforeseen elements that I can't necessarily predict.*

*Do I work to a routine? I tackle every project or commission differently.*

*Equipment: Leica compact, full 35mm Nikon outfit, Pentax 6x7 kit and a large format camera. I use Polaroid Type 55 5x4" pos/neg film in the studio, some of which I solarize during processing. Using this type of film allows me greater control over the subject and the end result.*

*I always carry a small camera with me, but that is not to say I am constantly taking photographs.*

### Darkroom work

*Do I work to a system? Yes, when doing specialist types of printing such as lith. It calls for specific concentrations, temperatures and times to gain specific results. With 5x4" work, I generally get the negatives to where I want them during the shoot.*

*With other work, choosing a negative means looking at contacts. I like to view these over a period of time. Sometimes I make proof prints before choosing my final selection.*

*Print exposure methods? In respect of lith printing, print exposure is determined right down the line from producing the negative that is suited to the process.*

*I find a certain amount of under-exposure gives the feel I am looking for.*

*What qualities do I look for in a print? I try to gain a richness and depth that can be created by using certain papers and chemicals.*

*I often spend a whole day working on a print and can come back to it several times.*

*Equipment: Besler condenser and De Vere 504 enlargers.*

*Do I laugh in the dark? Yes, when there is something funny on the radio.*

### Post darkroom work

*I use fine brushes to hand-work small prints with bleaches and toners.*

*I acknowledge computer technology's fantastic capabilities, but have not chosen to use computers in my work to date.*

My own favourite image here is one of the boxing portraits. Although all the others are beautifully hand crafted images, this image has a quality which captures a real moment in time.

I feel my work has changed dramatically, as these images were taken between three and five years ago, so at the time I looked up to people like Alfred Stieglitz and the pictorialists for the beauty, depth and quality in their work, whilst I also greatly appreciated the work of Joel Peter Witkin as an image maker, making one-off originals by hand-working the print.

Has this image been successful? From a selling point of view, of fine art prints, it has been.

**Untitled 1994-5**

*A personal image made for an exhibition, inspired by the work of Joel Peter Witkin and Francis Bacon. The photograph is a small 5x4" contact print, hand-worked with chemicals.*
*I like the image for its mysterious quality.*

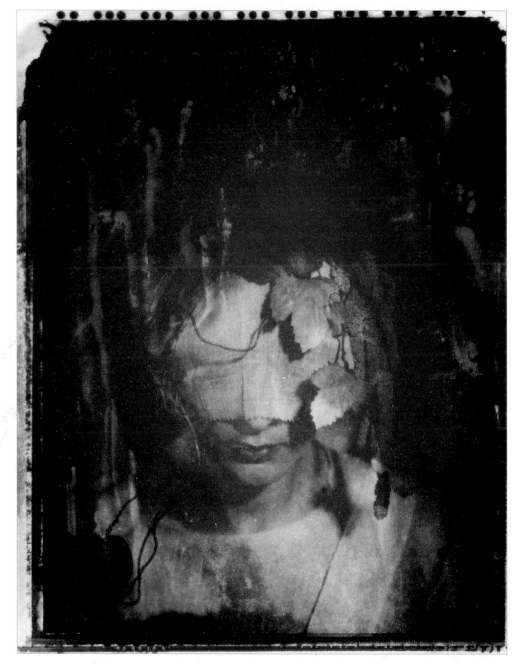

*We all have our own way of seeing. To really see something is to take it in.*

*Yes I am a perfectionist.*

*My work is as much for other people as it is for myself. I want people to take an interest in it and discuss it, whether they like or dislike it.*

*I don't take holiday or fun photographs as a rule.*

*I like working on my own, but most of my work does involve other people.*

*previous page:*
**Boxing portraits 1996**
*Personal images for an exhibition, inspired by old boxing movies. I like their subtle and sensitive nature.*
*The prints are lith and although my work has changed, I still fully appreciate them today.*

*Is photography about spontaneity or reflection? I would definitely say elements of both - they are equally important in different situations.*
*I do think photography is a gift but in order to promote your gift you have to graft.*

*A photograph is a powerful form of communication.*

*Mistakes can work to our advantage sometimes. Obviously disastrous mistakes teach us to try an alternative way of doing things.*

*A photographic wish would be a world-wide commission that would allow me to produce the work I want to do.*

*this page and opposite:*
**Untitled 1994-5**
*More personal work for exhibitions. The image opposite was used for a book jacket.*
*The prints were made on Kentmere Art Classic.*

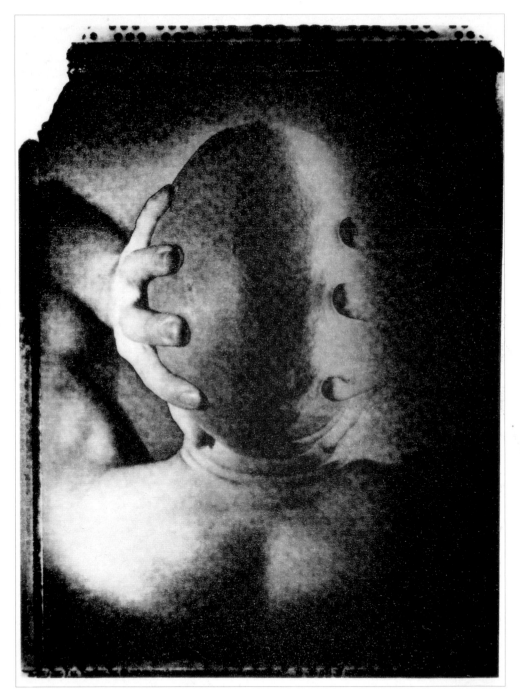

# Alice Rosenbaum

**Status** Working towards being professional. I'm part-time at present.
**What** else do I do? I process film at a specialist black and white lab. Also, I work with a band, creating visual ideas, flyers and CD covers etc.
**Inspired** to become a photographer when I got a camera for my eigth birthday, and I was hooked.
**Learnt** photography by simply picking it up along the way. Later improved my printing skills at college.
**Favourite** photographer is Robert Frank. Favourite photograph? I like too many photographs for too many reasons.
**Best** critic. I don't think it has been one specific person or thing, criticism in general is always helpful. Best criticism? I have had several comments about my images being cinematic. This is valuable because it confirms that my underlying aim is coming across. I'm always interested in what people have to say; it gives me perspective.
**Aspiration** is to produce affecting, emotionally charged images.

### Technique

*I appreciate technique, in so far as it enables me to achieve my aims. I'm not interested in it for its own sake.*

*You learn graft. You can't learn the gift.*

### Camera work

*A camera helps me to appreciate the details.*

*I find it incredibly exciting to be able to capture what I see, and how I see it, on to film, taking that image out of reality, separating it and preserving it.*

*I don't plan. What I see through the lens dictates.*

*No, I don't work to a routine.*

*Equipment: I mostly use natural light, black and white film (Tri-X). Nikon FE, 50 and 28mm lenses, Yashica 6x6, and older cameras that I alter, to allow various film formats.*

*I do try to always carry a camera with me, but sometimes I just want to experience certain events.*

### Darkroom work

*I don't employ a system.*

*From the contact sheet, I pick the ones that I feel have potential and do rough prints. Having studied the roughs, I make my final decision.*

*Sometimes I can tell from the negatives and go straight from there to the final print.*

*What print exposure methods do I use? Simple ones, dodging, burning-in and flashing.*

*I don't know if there are a set of rules that determine what makes a well balanced print. It depends on the image.*

*What other qualities do I look for in a print? I don't have a check-list, I just know it works for me.*

*Making a print can be very quick, although long exposures, long lith development times, washing and toning etc, can prove time consuming.*

*Equipment: Durst Laborator enlarger, Champion Novolith and Ilford PQ universal developer, dodgers etc.*

*Do I ever laugh in the dark? Yes. The moment when I realise it worked better than I imagined. Especially with lith, it feels as though there is an element of magic involved.*

### Post darkroom work

*Bleaching, selenium and gold toning.*

*I don't use digital techniques.*

*Listening for the sound of your keys in the door.*

### Waiting

*The inspiration for this photograph was partly testing a technique (35mm film in a 120 camera,) and partly documenting the empty room.*
*The print was made on Kentmere Kentona paper, lith-printed and selenium-toned.*
*I am happy with the picture, in part, because as an experiment it was successful because I captured the emptiness of my surroundings as I waited for something to happen.*

*What determines whether I like a photograph? The indefinable thing…whether it affects me.*

*I like all three pictures here equally, because I managed to take what was in front of me and transform it via the camera.*

*Apart from sight, hearing is my most important sense.*

*I think looking and seeing are the same thing. The difference is between looking/seeing and really looking/seeing - trying to get beneath the surface.*

*Unfortunately for Jen. She was out the night a cat accidentally got trapped inside her flat*

I am not a perfectionist - in a strict technical sense, but I have my own standards.

When I am taking the photograph, I think more about documenting the moment than I do about the look of the finished print. (That comes later.)

Photography is a combination of spontaneity and reflection.

What can people see of me in my work? Different photographs show different facets. Obviously it shows how I view the world.

**Jen's Room**
*(Unfortunately for Jen she was out the night a cat accidentally got trapped inside her flat.)*
This picture was part of a college project designed to portray people through their living space.
I used an old Ensign Carbine camera, deliberately letting the images overlap.
The print was made on Sterling,, lith-printed and selenium-toned.
I'm happy with the result, not only with the aesthetic qualities, but with the accompanying text it describes a detail of the subject.

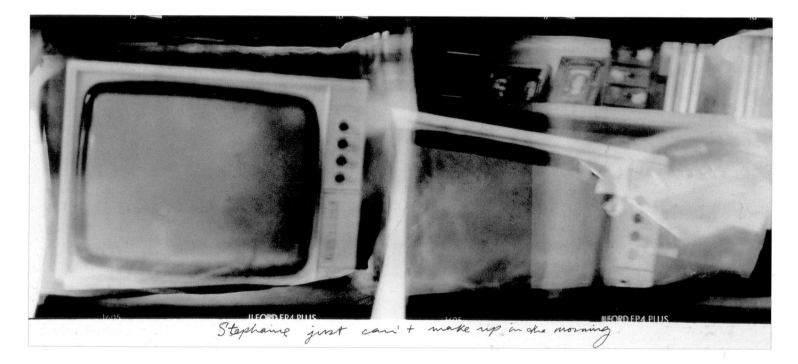

*Stephanie just can't make up in the morning.*

**Stephanie's room**

*(Stephanie just can't wake up in the morning.)*
*Another image for the college project, mentioned opposite.*
*The print was on Sterling, lith-printed.*

I don't follow any particular rules. I'm sure there are unconscious ones, but any rules I may follow, I'm quite happy to break.

Mistakes always teach me something.

A photographic wish would be more camera, more film, more time.

The finished print is what you imagined you saw.

# Dario Rumbo

**Status** Full-time professional.

**Inspiration** to become a photographer? I don't think any one person, or thing in particular, inspired me to become a photographer. I always had a need inside me to do things, and photography became the major and the most important one. This has never changed over the years. I am inspired to be able to reflect all the ideas that are in my mind, and make them accessible for other people. I try to put my ideas onto photographic paper and be constantly creatively satisfied.

**Learnt** my basic photographic skills in Spain, with a couple of friends, but then I decided to come to England and learnt formally at college. I am still teaching myself in a lot of photographic fields.

**Who** would I like to learn from? There isn't any individual in particular. I am very keen and happy to learn from all people.

**Favourite** photographer? Richard Avedon for his enduring success and simplistic approach. I have several who inspire me and they change depending on what I am doing. A favourite photograph is even more difficult to choose; that would be too absolute. I don't think this is possible for me. There are far too many very well made photographs.

**Best** critic? When you leave college, you don't have a tutor anymore, so you are forced to become your best critic. I know my work and my reasons for it better than anyone, so with honesty I don't think there is a better critic. Best criticism? 'This work you show me is not really that brilliant, but you do realise that no one can be brilliant all the time, every time.'

**Aspiration** is to be able to reflect all the ideas that are in my mind and make them accessible for other people.

### Technique

*I do like technique, and I always think that it helps immensely to put ideas successfully on to photographic paper. The only problem is that one can get really trapped by it and then creativity can be hampered. There is a learning process that you must go through, in terms of technique.*

### Camera work

*The camera opens up my view of the world. People could say that you only have a restricted view with that frame, like a window, but what you have is a control over it. I always have ideas in my mind, that I need to get out, and normally I configure these ideas before I actually take a photograph. However, this depends on how complex the idea might be.*

*A routine? Not really. I try to be versatile, so I work in different fields, this allows me to remain stimulated and inspired. Too strict a routine would restrict my potential for experimental photography.*

*Equipment: I have two 35mm cameras, one is a range-finder compact, the other is an SLR, with 28mm, 50mm and 135mm lenses. Also I have a 6x7cm camera with a 90mm lens and I use a Polaroid Land camera and a pinhole camera, to play with - becoming a child when I do.*

*I carry the compact at all times. I use it as a diary to capture momentary images.*

### Darkroom work

*I don't think that I am that systematic. I choose a negative by looking at the contacts. From there I look at the composition more than exposure. I don't use a print exposure system, when doing lith. For straight black and white, I use Multigrade paper and split-grading. I just use common sense and economy.*

*I don't think there is a strict rule to determine a well balanced print. It's down to taste. How long it takes to make a print varies, depending on how well I know the negative. On average it is two to three hours. My frame of mind has a lot to do with it. I don't print when I am tired or stressed.*

*Equipment: a Beseler 23II with an Ilford Multigrade 500 head, plus a variety of lenses and the usual focus finder, easel and dodgers.*

*Yeah! I am still having a great time printing especially when results come up to my standard. A surprise in the darkroom makes me laugh and when by mistake I get a unique print, then I am happy too. These prints haven't got the Ansel Adams quality but they are 'perfect' and unique in their own right.*

### Post darkroom

*Just spotting. Digital work? Only when the photograph has to be outputted onto something other than photographic paper and then as an Iris print.. Digital provides the chance to work with different people in different countries.*

It is sometimes difficult to recognise what people are teaching me, but it is always down to me to extract that knowledge; from whom or what field does not matter.

I find technique appealing, and a challenge when I am able to combine and choose successfully from a wide range of them. Technique is as important and as fundamental as having 'a good eye'.

After a photograph has been taken, you will be surprised with the amount of new things that all of a sudden appear in the contacts that you didn't see in the viewfinder. Also, you have the facility to associate ideas and meanings to create a personal language.

I have seen prints with no shadow detail that impressed me. I would like to have three dimensionality. Some people call it depth.

**Untitled**

*A personal image. The inspiration? Not inspiration, but improvisation.*
*Kentmere Art Classic paper, lith processed in a very hot, weak solution.*
*I feel that this picture would never have happened if the model and I had decided to prepare anything on the day of the shoot.*

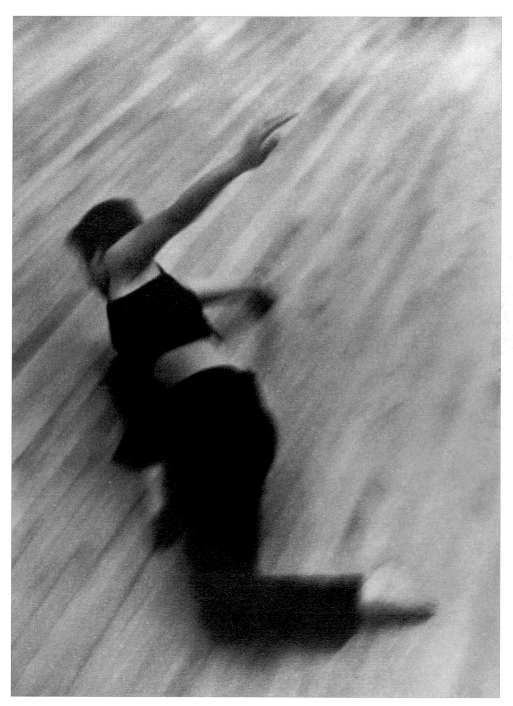

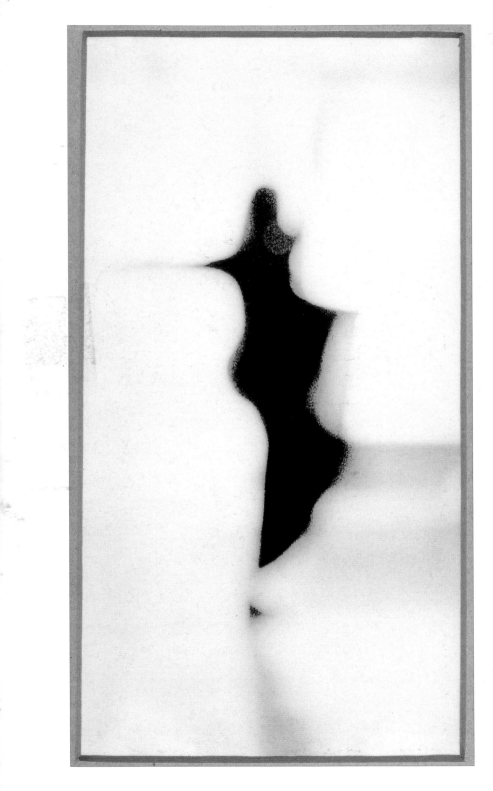

As we say in Spanish, a picture paints a thousand words, I would feel I was in photo heaven if images were the only available language.

I am married to photography in sickness and in health. I hope it will continue to be a fruitful relationship till death do us part.

Imagination is important. I always refer to it as a tool for inspiration and creativity.

My own favourite photograph is the one on this page. It has the simplicity, suggestion and subtlety that prevents an image from 'going off'. My preference has always been for the minimal, and that is frequently reflected in my work. I always try to keep in mind that less is more and I believe that applies to this picture.

The 'success' of an image is contextual and subject to change.

I try to put my ideas onto photographic paper and to be constantly, creatively satisfied.

There is a body function that is working all the time, that could be called looking, but seeing is a more complicated concept, that has a prescriptive control over what we look at.

**Dance I**
*Personal work.*
*The choreography of a friend of mine based*
*on the book 'The Mill on the Floss'.*
*Printed on Kodak TP5 paper and lith*
*processed.*

Seeing can be a global sense that allows us to put concepts and ideas together in our mind. For me, this is sometimes the first step I take in the photographic process, but we don't really need a camera to see and I think I should be able to enjoy 'seeing' without one. I call it 'just seeing for the sake of it'. I don't think looking is any different to breathing, for example. It is just something that we do all the time and is natural.

I do value criticism. Unfortunately photographers are often too engrossed by their own work to give criticism. Visual people don't talk enough about other peoples' work. This is a price we photographers pay because of our isolated way of working.

Mistakes are part of a steep learning curve. They can also make you insecure. However, they should give you a more refined and wise personality.

I am a frustrated perfectionist. I feel that perfection is an unachievable utopia. I haven't developed a device that protects me from this problem quite yet, but I am learning slowly.

All my creativity is channelled into photography and its associated disciplines. This occupies my mind and my time almost exclusively.

I have learnt that people from different backgrounds look at photography in different ways and this creates new audiences that I hadn't anticipated when I first created the work.

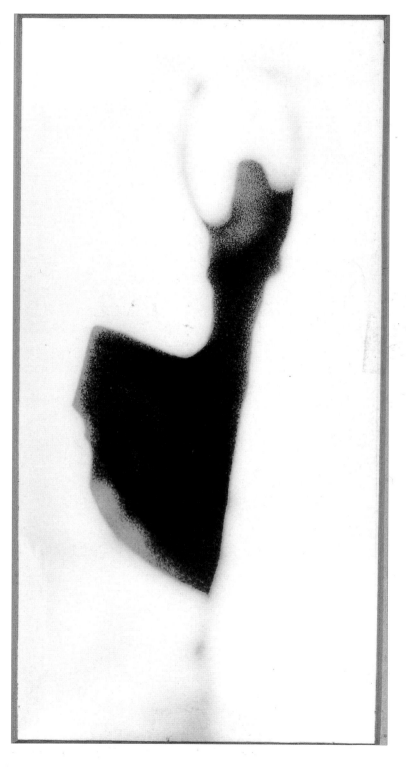

**Dance II**
Another personal work, also printed on Kodak TP5 and lith processed.
I think I couldn't repeat these images for personal reasons, but they are two of the most successful images I ever produced.
I still like them very much.

# Philip Thomas

**Status** Professional.

**What** else do I do? I direct, mostly television commercials. I do bits of journalism, fiddle around with web sites and write.

**Inspired** by a book by Christopher Isherwood called 'Farewell To Berlin', or something like that. It was turned into a play called 'I Am A Camera', eventually it became a movie, called 'Cabaret'.

**Learnt** photography by buying a light meter before I bought a camera. I used to drive people nuts. All the time I'd stick it in and around what they were doing. Once I'd got used to the idea of light, and how it changed, I bought a camera.

**Who** would I like to learn from? I'm not very good at learning from other people. Essentially I'm solitary.

**Favourite** photographer? Capa. He was a man of his time and very brave. He photographed what was going on around him. Favourite photograph? Gered Mankovitz's picture of Jimmy Hendrix. I met Hendrix three times. He had this wonderful smile, he looked like a guy who was about to roll a joint. Gered got it hole in one. Always cheers me up, that picture.

**Best** critic? I like to read articles by photographers or about photographers, particularly essays at the front of the big, heavy, American art books. Best criticism? I'm not aware of any, good or bad.

**Aspiration** Not very much. More to do with what I don't aspire to. I don't aspire to being a technician, and I don't aspire to being a photographer; it's a highly prejudicial term. In moments of gross vanity, I aspire to style.

### Technique

*Sounds hard, but once I've developed a technique I despise it. You can make a good living off technique but in the end it comes round the back and kills you, you're just a one-trick pony.*

*Rules? I try and keep the camera at about five foot and make sure there's more out of focus than in focus. These are rules I more or less try and keep.*

*Mistakes? They're useful. More than useful. Embarrassing when they happen, but vital for the future.*

### Camera work

*A camera doesn't open up the world, it sticks it under the microscope.*

*Do I see the image in my mind before I photograph it? Never. Qu'ai sera, sera.*

*Do I work to a routine? There's a word in German - Kriegesberechschaft, it means the joy of the contemplation of going to war. If you're doing a big shoot, it's all in the preparation and logistics.*

*Equipment: it depends on what I'm doing. Cameras have a personality which transmit themselves to the subject. I use an Olympus OM1On, 35mm SLR. I tend to favour fairly low shutter speeds and hand-hold the camera..*

*I always carry a camera, but. I wouldn't in Syria. They have the worst jails and carrying a camera in a country like that is an invitation to get banged up.*

### Darkroom work

*Do I work to a system? Yes, it involves getting someone else to do it.*

*I spend a lot of time going through contact sheets. It's quite interesting going back on old work. Immediacy makes you look at pictures in one way, but they're a bit like fruit and oak trees. Give them a bit of time and they sometimes ripen up nicely.*

*If I've got to turn pictures round quickly, I go for fast, gut reaction. If there's more than one similar shot I take the one with the least technical flaws.*

*I hate mid-tones. As long as it's got contrast, minimum grain, not on glossy paper and a bit of a punch to it, I'm happy.*

*What other qualities do I look for in my prints? Excitement.*

*Prints are subjective. My view of them is that they change with the way I feel.*

*How long might it take to make a print? Not my department.*

*Equipment: find a good printer, or a printer you like, hand over the negative, the contact sheet and some money and it usually produces quite good results.*

*Do I laugh in dark? I don't like printing. I can't stand the smell.*

### Post darkroom work

*I hate retouching. It kills shots stone dead.*

*I am about to go the full techno. Shots on disc make life a happier place.*

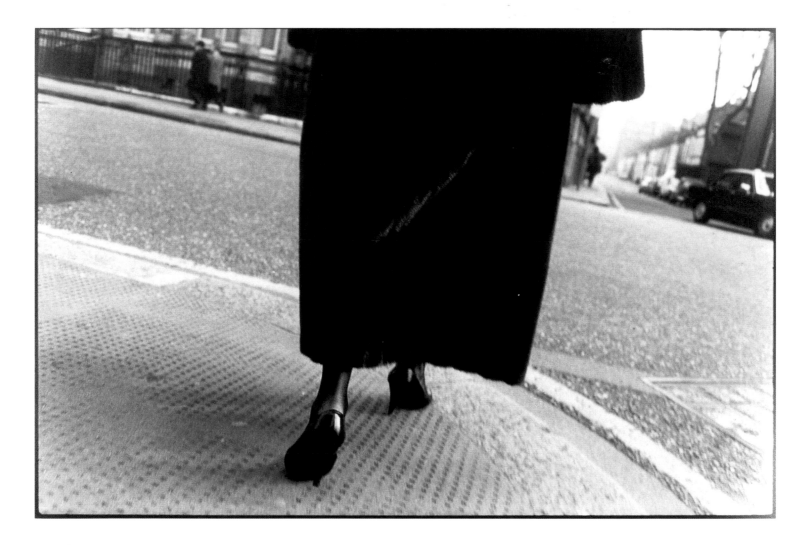

### Knightsbridge

*A commissioned work, shot as part of a storyboard
for a TV commercial. An American agency wanted
something slightly retro - with a Norman Parkinson
feel to it. They felt London was sufficiently distanced
from the USA to make the time unfamiliar.
The shot was part of a series taken to test angles,
lenses and style of composition.
It worked very well.*

*Technique is different from ways of doing things. Recognising light is part of
technique, but it's not a technique in its own right. Getting somebody to react with
the camera depends on certain techniques, but as long as you're wide open and
flexible you get fresh results more or less every time.*

*I think the advantage of techniques is that they sometimes get you out of a hole, you
get a shot you wouldn't normally be able to get when you're tired, the light's rotten,
the subject hates you, you're frightened or whatever. They're also a path onto
something fresh and new. By knowing something works, you can try something you
haven't done before in reasonable certainty it's going to work.*

*Do I value other peoples' opinions? I try to be even, I listen to what they say, good or bad.*

*My view is that photography is subservient to the person behind the camera. The personality comes first, the photography - always assuming a certain degree of skill or confidence, whatever, comes second.*

*The camera is a killer and sometimes it kills the person behind it. Look at Diane Arbus; she spent so much time photographing people in lunatic asylums and depressive houses she ended up killing herself. Don Silverstein, who was great black and white photographer, killed himself on Hampstead Heath. A lot of photographers, particularly reportage photographers, have ended up swinging from the rafters. At one stage I was just compulsively photographing weirdo's and it really got to me. Some of the pictures were very funny, but they were also extremely sick. I made myself photograph flowers for three months.*

*The only routine I have is making sure things work, which takes a lot of forward planning.*

*My own favourite photograph is one of my sons on the Eiffel Tower. We'd gone to Paris to cover the start of the Paris-Dakkar race, and I thought it would be nice if they came along. They had these big raincoats that flapped around and we went up on the tower when it was blowing. I got a grab shot on a manual camera set-up for whatever the last shot was. It was a very, very happy accident. As to why I like it. Well, it's more than just sentiment. I like pictures that move. I like shots that have a large emotional content, movement, and a sort of hand-drawn feel. I think this one does it quite nicely.*

*What determines whether I like or dislike a photograph? It's like any kind of art: writing, movies, music. There's one simple test, does it change your life? Doesn't have to be for long, could be just a minute, could be a day, could be for life. Just as long as it changes you, it's done its job.*

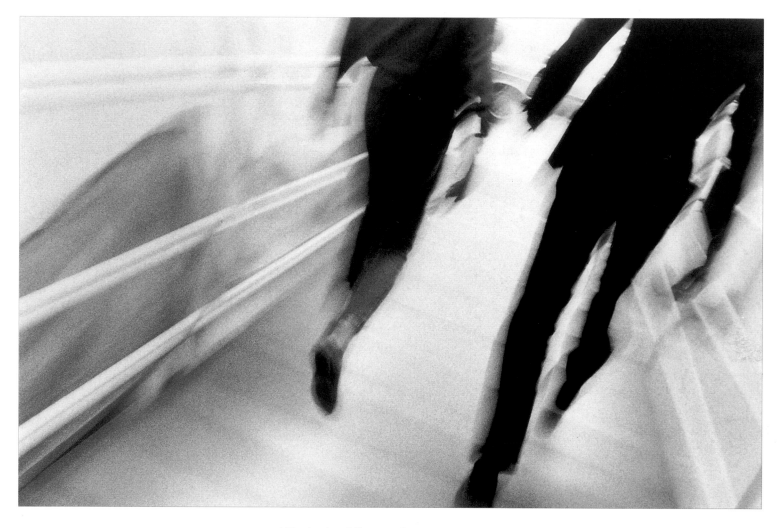

**Catherine Hamnett**

*A commissioned work. At one time Catherine Hamnett had a shop in the Brompton Cross. People would walk in to it in a very excited fashion. The clothes had a peculiar, but pleasant sexual undertow. You felt they never promised anything they couldn't deliver. You sometimes see couples in restaurants and you know 'What's For Pudding.' The entrance to the shop had that sort of 'What's For Pudding' feel to it.*

*The picture was made with an Olympus OM1 using Ilford HP5.*

*What's the difference between seeing and looking? One's active, one's passive. I don't think looking is as useful as seeing. If you look you sometimes end up with things that aren't there. Looking is very close to paranoia and the problem with paranoids is that they're sometimes right. I think you have to be fairly relaxed or confident to see. Under pressure you tend to look and it doesn't always produce the best results.*

*Am I a perfectionist? Technically, no. I'm not a big hitter on f stops and shutter speeds. I'm a perfectionist if I don't like a shot, but I don't use perfection to try and get it. I've noticed that imperfection is one of the vital ingredients of perfection. If you listen to tapes of really great comedians, they're full of fluffs and technically the timing's rotten but they add up to something that's great. I think mistakes are an essential part of perfectionism.*

*My photographs are for Me, God, money, my kids. I don't know.*

*No. No. No. I don't take holiday photographs.*

*Some people like to plot and plan; I like things to happen. For me, it's a performance art. The thing about photography is that it's a fast art. Music you sit down and have to compose; a screenplay is hours and hours of re-writing; painting is a long journey. Photography is right there in front of you. Press the button and it's all over in a 1/125 of a second. That's photography's strength. You want to take hours and weeks over a picture, be a painter.*

*You can learn it. I did. I suppose left in my natural state I've got a 'tin' eye. I kept bashing and bashing away at it and in the end I produced something I quite liked and a few other people did, too. There are people around who are genuinely gifted, they can see light and composition like other people can see the number on a double decker bus. For most of us, though, it's just practice, practice, practice and sling your mistakes in the waste paper basket.*

*What is a photograph? A good one changes your life, your attitudes and your beliefs. On another level you hold the past in the palm of your hand.*

*Is there anything about the solitude of being a stills photographer that appeals to me? I like the idea about being part of events, and yet at the same time being apart from them. Like it not, when you photograph there's a screen between yourself and what's going on in front of the camera.*

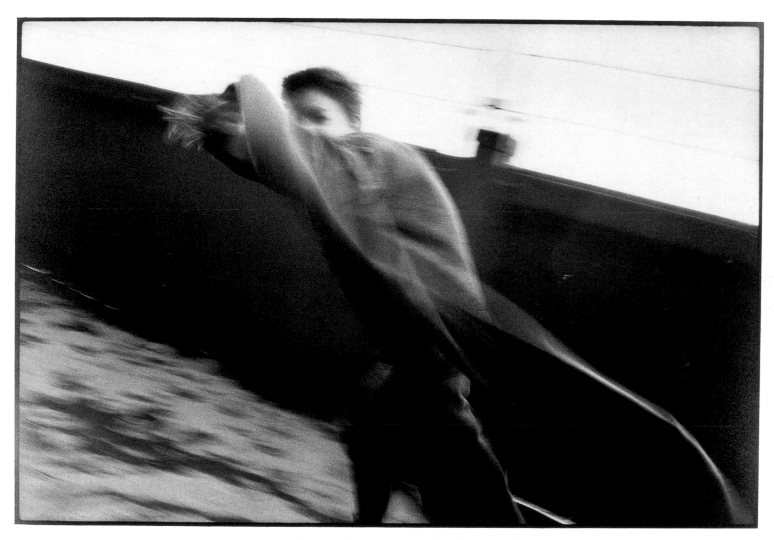

**Eiffel Tower**

*A personal image, inspired by the wind, a strange place, a child's excitement and the flowing coat. The print was made on Ilford Multigrade, RC, pearl. How do I feel about the image? Press the button first, think about the technicalities after. I'm very pleased with the picture. It's the kind of shot I try to replicate commercially.*

Imagination plays no role at all.  None at all.

What can people see of me in my work? Nothing I hope.

# Michael Trevillion

**Status** Full-time professional.

**What** else do I do? Cooking.

**Inspired** to become a photographer when I left school. I had no idea what I wanted to do, my father, a bricklayer, knew another bricklayer who had a son who had a lab; I got a job as a messenger. That's why I am a photographer.

**Learnt** by watching over peoples' shoulders and asking questions.

**Who** would I like to learn from? Nadav Kander. He uses colour beautifully. I would like to know how.

**Favourite** photographer? Me really. I don't really look at other photographers much. Favourite photograph? Any old photograph that depicts people or places that are no longer around.

**Best** critic? As above. Best criticism? Someone said I lacked subtlety - but that's bullshit! People don't say much, but my images sell regularly, so I take that as a compliment.

**Aspiration** To make a good living taking the same pictures that I would if it was just a hobby. I'm nearly there.

### Technique

With so many photographers around, it is unfortunately necessary to have a style that you can be known for. This is a shame but that's the way it is.

If I was a good chef and magically mixed herbs and spices to make a sublime dish you wouldn't ask me what I was trying to say, just that the food was superb. I don't know why good photographers should be seen as anymore than mixing light, shapes, developers, papers to produce any images that is pleasing to the eye and left at that.

I hope I don't have any rules.

### Camera work

Does the camera open up my view of the world or frame it? I think I always looked at the world as if through a camera, so no difference.

Do I work to a routine? No, none at all.

To get a shot, yes I am a perfectionist. I go to enormous lengths, after that, I'm in the darkroom and out ASAP.

Sometimes I have a shot in mind; sometimes I just react to what comes into view. I am very good at imagining how light on a certain scene will react with a certain film in my camera and how that will look in the final print, but apart from that, not much.

Equipment: battered old Olympuses, the tattier and more beaten the better, so I can treat them without care. Sometimes a Pentax 6x7 for serious landscapes. Do I always carry a camera? I am trying to make it my golden rule.

### Darkroom work

Do I work to a system? None at all; nothing I could write down anyway.

What process do I go through in deciding which negatives to print? The same gut reaction. I don't even need a contact sheet.

Do I use any exposure methods. Sorry, none at all.

What determines a well balanced print? Gut reaction.

At what point am I satisfied with a print? Five minutes after I get in the darkroom. How long does it take to make a print? Five minutes maximum.

Equipment: De Vere 5x4", Multigrade head, one dodger and a pair of hands.

Do I ever laugh in the dark? Get real! This is my job!

### Post darkroom work

Just toning. I am opposed to computer manipulation, as I feel it is cheating the viewer. Even toning I am becoming anti to; it's so often an excuse for a bad shot. Computer technology doesn't really open up any new opportunities, except for keeping track of negatives, sales etc.

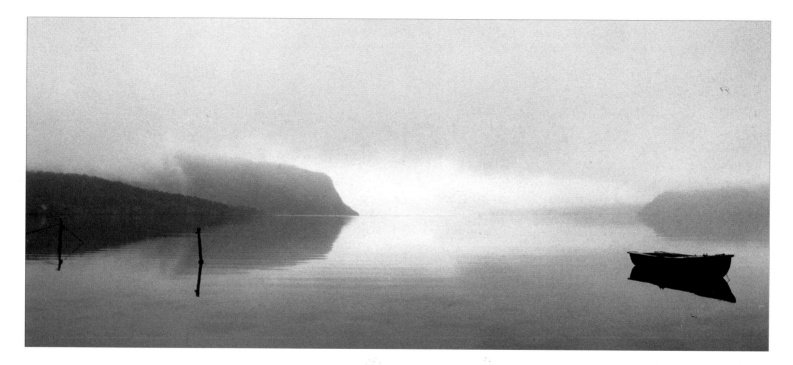

**Boat on Fjord Norway**

*My favourite photograph is the one above. The boat on the water is like an old friend. As the scene came into view, I was driving along a tree-covered road at dawn in Norway, I crashed the car in my excitement. It is pretty much my most successful image.*

*Gut reaction determines whether I like a picture or not. I want to keep it that way so I don't think about things like this much.*

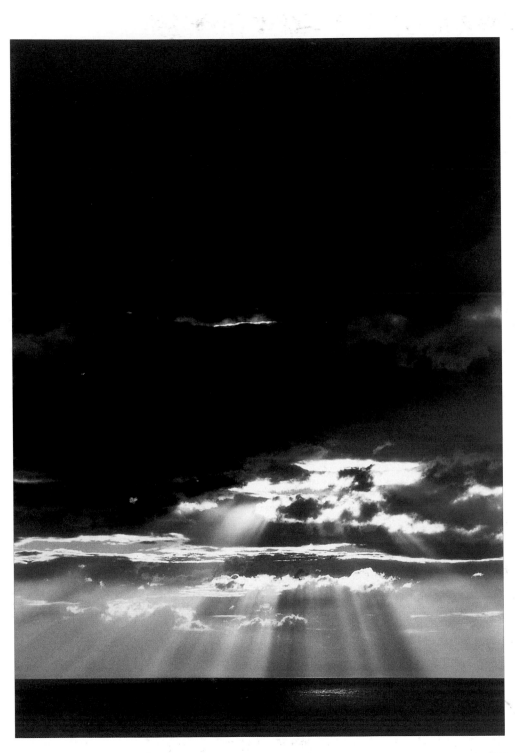

Who are my photographs for? Obviously, if I have a brief to follow, the shot is to satisfy the client, but if not, I probably always have a sale in mind.

I automatically see book titles in the viewfinder. I work in book publishing because it is perhaps the only way I can get paid for taking the same pictures as I otherwise would do for fun.

**Cloudburst, Sicily**

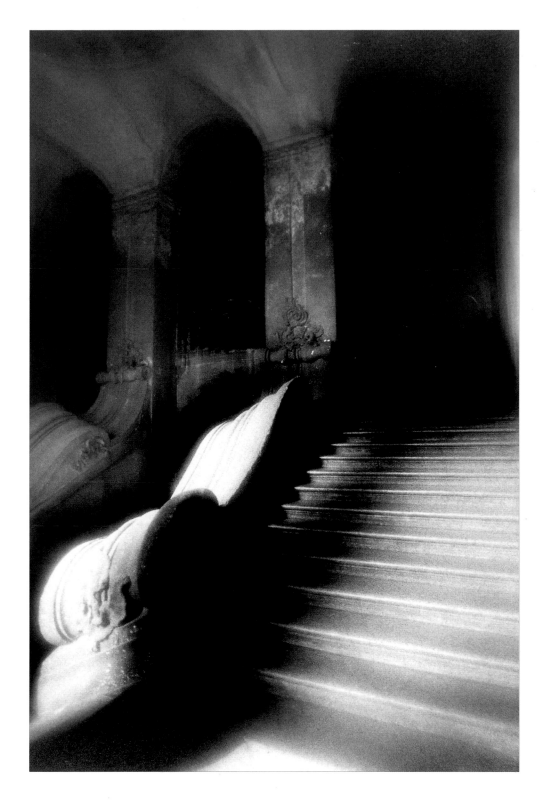

*Stairway, Sicily*

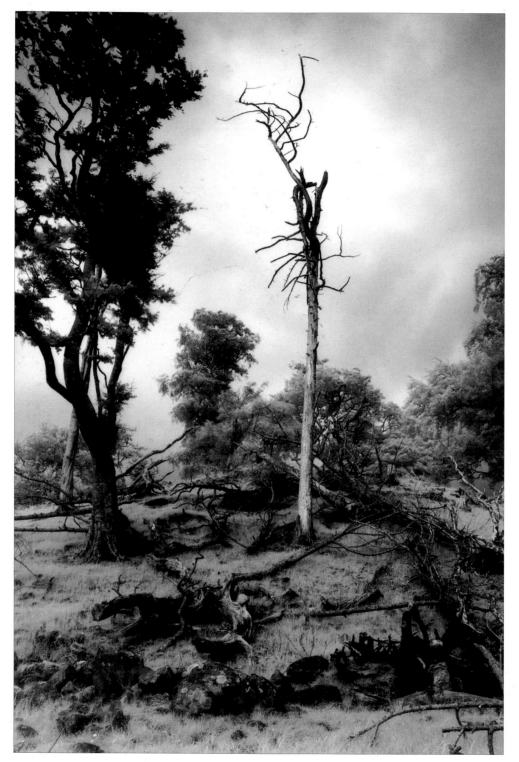

I have probably become a photographer because I have always been an outsider, looking in on life, but I wouldn't say that's not something I wouldn't change if I could.

Is photography a gift or graft? A bit of both. I have an 'eye', undeniably, but it's been honed by hard graft.

**Tree, Scotland**

130

*A photograph is something that can be pleasant to look at, but I don't think a photograph could ever inspire anyone (except another photographer) unlike a song, for example.*

*What can people see of me in my work? Not much, perhaps a longing to be a fish.*

**Waterlillies, England**

*Photo heaven is the idea of going off to Scotland or Iceland, as I do, with no particular deadlines or shots in mind.*

**Statue deep in thought**

*A photographic wish would be that publishers, who well-know the importance of a book cover, paid accordingly.*

**Evil Eyes**

# Brian Wells

**Status** Amateur/part-time professional.

**What** else do I do? Nothing at present. Without doubt, photography is a passion. However, for recreation I enjoy cooking, mostly savoury dishes.

**Inspired** to become a photographer by an enthusiastic teacher, Mr. Shreeve. He taught non-exam photography at my local high school in Caister-on sea. From that moment on I had my heart set on becoming a press photographer.

**Learnt** the fundamental basics of photography at high school, where I was able to process and print black and white. Who would I like to learn from? Simon Marsden. I greatly admire his technique in the way that he captures the decaying landscape. His work conveys a sense of mystery, stillness and desolation.

**Favourite** photographer is Simon Marsden. Favourite photograph? It's difficult to choose a single favourite photograph - there are so many that I admire. I was a great lover of old-fashioned photographs, taken before the First and Second World Wars. It's frustrating to see how times have changed.

**Best** critic was John Hansell, my second year photography tutor. Best criticism? Sticking to what you're best at, not to be a Jack of all trades, master of none. I do value what people say about my work.

**Aspiration** It would be great to find work outside the Yarmouth area - people expect you to work for a pittance. I am currently in the process of producing a set of images shot in East Anglia, showing the derelict and decaying landscapes. It's an ongoing project. I would like to stage an exhibition and see more work published.

## Technique

I love many aspects of the various skills required in this medium.

For instance, determining the - my personal - exposure for a particular scene, deciding upon the most suitable choice of film for the subject, will it benefit from the use of filters?, what about diffusion?, and framing the subject correctly is also another factor.

As for specific techniques? Nothing really springs to mind.

## Camera work

I find that the various decaying buildings/landscapes that I record on my travels have made me more aware of the ever changing landscape that surrounds us. Most of the time I will spot something that I think is of interest and return when the light is right (it usually isn't at the time).

I always shoot on 120 format (6x6cm) and when printing I produce an image that is usually 10x10" on 12x16" paper.

Equipment: Rolleiflex 'T', small Gitzo tripod with Manfrotto head, pistol grip, filters: green, yellow, orange, red, polarising, neutral density and various diffusion filters. I've just bought myself a 1928 Kelly's Directory of Norfolk and Suffolk - an indispensible reference book.

I carry a camera all the time.

## Darkroom work

I don't work to any particular system. How do I decide which negative to print? Composition, exposure, details in the highlights and shadows.

Flashing is an important method of print exposure for my work.

A well balanced print is one with a pleasing composition, correct exposure, contrast, and toned accordingly. I also like a wide tonal range.

I am satisfied with a print when I have accomplished the above functions.

It can take up to one day to make a print.

Equipment: De Vere 203 condenser, 75mm Rodagon lens, Beard easel, below-the-lens filters, and a flatbed drier.

I make test-strips for assessing correct density, contrast, burning and dodging. I employ flashing, split grading, split grading plus multiple grade burning, bleaching, print toning, multiple toning and hopefully lith printing again soon.

Laugh in the dark? No, not now, however I used to while studying photography at college.

## Post darkroom work

Nothing other than copying work onto slide film.

Most of my prints are window-mounted by myself, using white museum board and then stored in Secol sleeves.

Which is my favourite image? Difficult this, as I tend to change my mind often. At the moment its 'The Attic, Seagate House', in Lincolnshire. This building is, or rather was, a fine example of Georgian architecture, which is in a very bad state of repair - it's a grade 2 listed building apparently. I was lucky enough to get inside it and see some incredible sights. I like the composition, the light and the soft pastel-like colours of this image.

My most successful image is a partially toned (thiocarbamide) black and white photograph of a 1960's dodgem on wasteground. It's been published a number of times, and has won me several competitions. It's my favourite image - a lot of time and effort went into printing it.

I don't like images that I know have been digitally manipulated. Also, I don't like colour images where you can specifically tell when a filter has been used. I think it's all about using a filter(s) to make subtle adjustments to a scene - to enhance it, but not to go over the top. I hate multiple exposure/special filters. I like well executed/printed, possibly toned images (black and white of course), that are window-mounted in white museum board. Any other colour I find detracts from the final image.

Apart from sight, hearing is my most important sense. I am an avid record collector of 70's pop, through to opera and jazz.

Seeing is being able to pre-visualise an image, to say whether or not a particular picture is going to work. Looking, I believe, is not having the ability to do this.

Am I a perfectionist? I would like to think so!

previous page:
**Dodgem on Wasteground**
Personal work. I was intrigued by the scene. How often does one see such a subject as this? I like the combination of colours, which I find very subtle. The print was made on Fuji colour paper, diffused during printing, using an anti-Newton glass.

opposite page:
**The Attic, Seagate House**
More personal work. I noticed this grand, imposing building in the middle of nowhere and just had to investigate. I was drawn by the composition, the eerieness and the stillness of the scene. Again, the print was made on Fuji colour paper, diffused in printing. I like the feel of the light on the floor and the soft pastel-like colours.

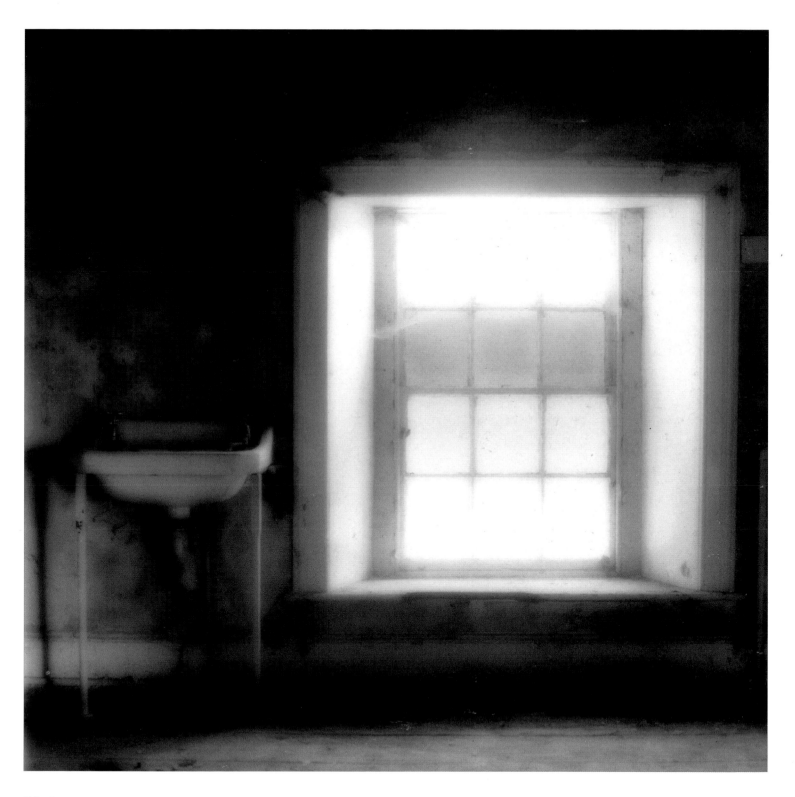

I have two daughters who I photograph as much as possible. These photographs are almost always spontaneous. I've never taken any photographs on holiday - I have never had a holiday. I used to work on a holiday camp though - yes, as a photographer.

I'm a bit of a loner really! I find photography most relaxing and I feel that it takes my mind off stresses and strains of everyday life.

Photography is about both spontaniety and reflection. I would say spontaneity means happening naturally, without planning - daylight being a prime example. Reflection means deep and careful thought which, of course, goes into every image that I produce.

I think that photography is a gift - a talent, providing that you can produce an image which at the end of the day you are pleased with.

What do people see of me in my photography? That I am artistic and a bit of a loner; curious I would think.

Mistakes have taught me to be more careful in the future.

Photo heaven would be photographing the subjects I love most and getting paid vast amounts of money in the process.

opposite page:
**Decay**
Another piece of personal work. I noticed that the door to a derelict property was ajar, so, again, I just had to investigate.
I loved the textures; I was also drawn to the mustiness of the scene.
The print was made on Kentmere Kentona. It has been processed using lith developer and toned in selenium for 10 minutes.

Imagination plays quite a large role in photography, I would say.

When I look at a decaying building, I will ponder as to what it was like when it was inhabited all those years ago - what were the people like for instance, who were they?

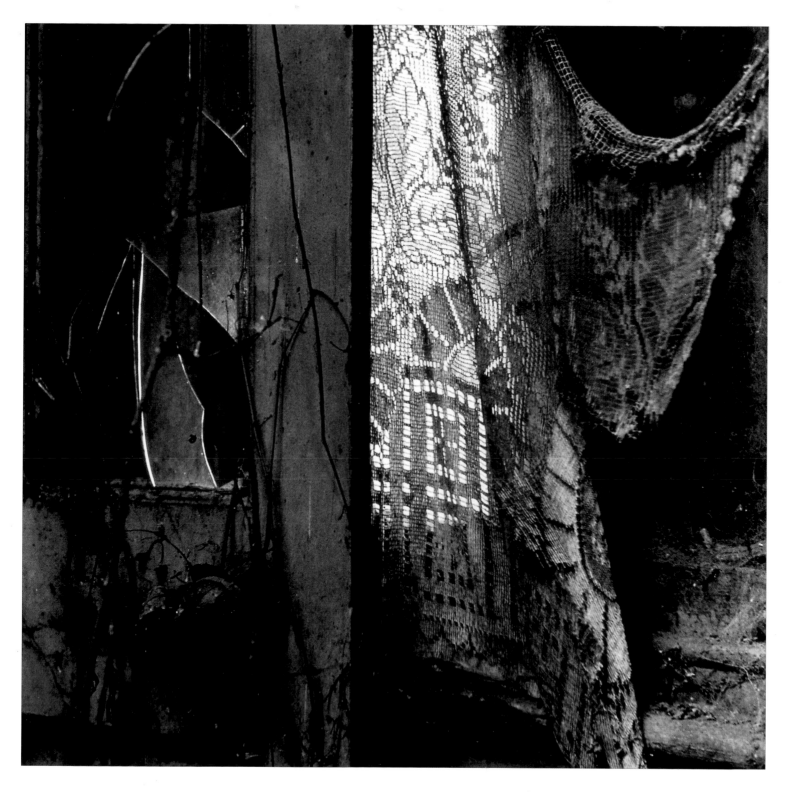

# David Woolfall

**Status** Full-time professional.

**What** else do I do? I make conceptual installations and write poetry.

**Inspired** to become a photographer from a young age. I felt I wanted to express myself, and through photography I have a tool for this need. In general, photography is very easy - it's very egalitarianism is its beauty.

**Learnt** photography by studying it at various levels and at college: NDD, HND and BA first class honours.

**Who** would I like to learn from? Christian Boltanski. Although not essentially a photographer, as such, he has an acute understanding of what a photograph says and means. Also Andre Kertez - because he had a real sense of 'time'.

**Favourite** photographer? I don't really have one, I like so many different ones. My favourite photograph is an image of my mum, dad and three sisters taken before my birth. The idea of seeing people prior to our existence is fascinating.

**Best** criticism is 'David, you're crap'. I value other peoples' opinions - generally it's easier for someone else to say they like something.

**Aspiration** is to create self-initiated projects, of a conceptual nature, for exhibitions and publications.

## Technique

*If it means the difference between good and poor results, we love to hate it.*

*I believe in 'No rules photography'.*

*Mistakes have taught me to learn fast. Sometimes the greatest results evolve from a mistake.*

*Imagination and creativity are everything.*

## Camera work

*Using a camera is a part of being subjective. It enables me to frame and contain my view of the world. In doing so, it opens up how I see others.*

*Sometimes I see the image in my mind before I photograph it. If so, I try to re-create what's in my mind's eye, as far as technique allows.*

*I don't work to any routine.*

*Equipment: describe it? No!*

*However, I would love to have a Mamiya RZ and to get paid to self-initiate work projects.*

*I don't always carry a camera.*

## Darkroom work

*What I believe in, is my bad printing.*

*How do I choose which negatives to print? I go with those that I consider to be the best.*

*What print exposure methods do I use? They are very basic. I count or use a meter.*

*What determines a well balanced print? I would say tonality, contrast and composition.*

*Mood is the other quality I look for in a print.*

*I'm satisfied with a print when I'm tired.*

*It might take a day to make one print.*

*Equipment: Durst and De Vere, trays, filters, paper, burning and dodging tools (hand-made) and chemicals.*

*Do I laugh in the dark? When I'm naked near a reflective surface.*

## Post darkroom work

*On a few occasions I use Photoshop.*

*Recently, I exhibited some work that I printed on to large canvases, via the computer.*

*Some photographers are indeed gifted. But these days it's incredibly easy to create an interesting image.*

*Technology advances as the gift of 'photo taking' wanes.*

*Which is my own favourite photograph? Probably the one of the feet. I find the image serene - which is how I felt about the person they belonged to. It reminds me of a lovely time in the past - this memory/time aspect in life - generally Proustian, excites me.*

*What determines whether I like a picture is a very difficult question to answer! There are many elements that create a good image initially. If the photography is technically fine, then it will not detract from one's engagement. Personally, after this level, I want to feel the photograph aesthetically or conceptually.*

*Smell and common sense are my most important senses after sight.*

**Untitled**
*A personal work.*
*A black and white sepia-toned print.*

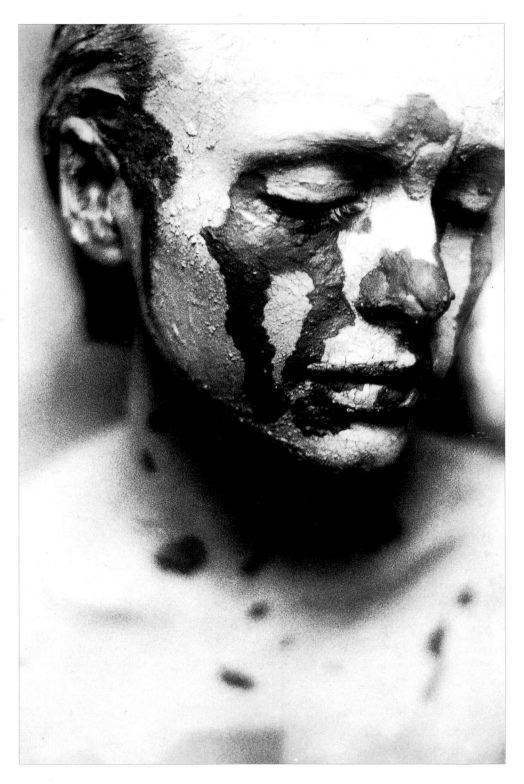

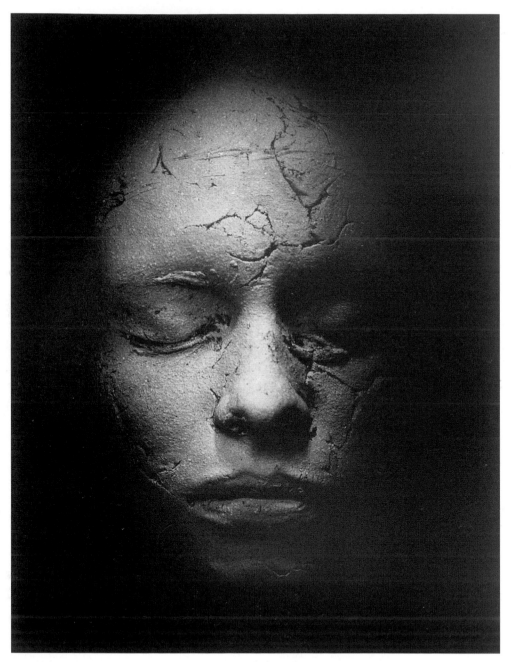

Seeing is perception, looking is visual grazing; yet looking often leads to seeing.

I do take holiday and fun photographs sometimes; often they're better! I would like to say they're more spontaneous, yet even 'domestic' images have a definitive code or schema. It's always fun taking these photographs - they concern memory directly.

Is photography about spontaneity or reflection? It depends on what photography you do. For me, reflection I guess.

What is a photograph to me? Too little space to write...not enough time to contemplate... too...

**Mask**
*A personal work, simply inspired by the model. I feel the image has a sadness about it, that represents an ending or a separation.*
*It is a straight black and white print.*

*No, there isn't anything about the solitude of stills photography that attracted me to the medium.*

*Photo heaven is other peoples' family albums and photographs.*

*These photographs here were essentially for me.*

*I am very happy the way photography is evolving in to a conceptual means of expressing our culture and time. More fine-art students and artists are embracing the photographic medium, which has had breathtaking results.*

**Feet**
*A personal image, printed straight in black and white.*